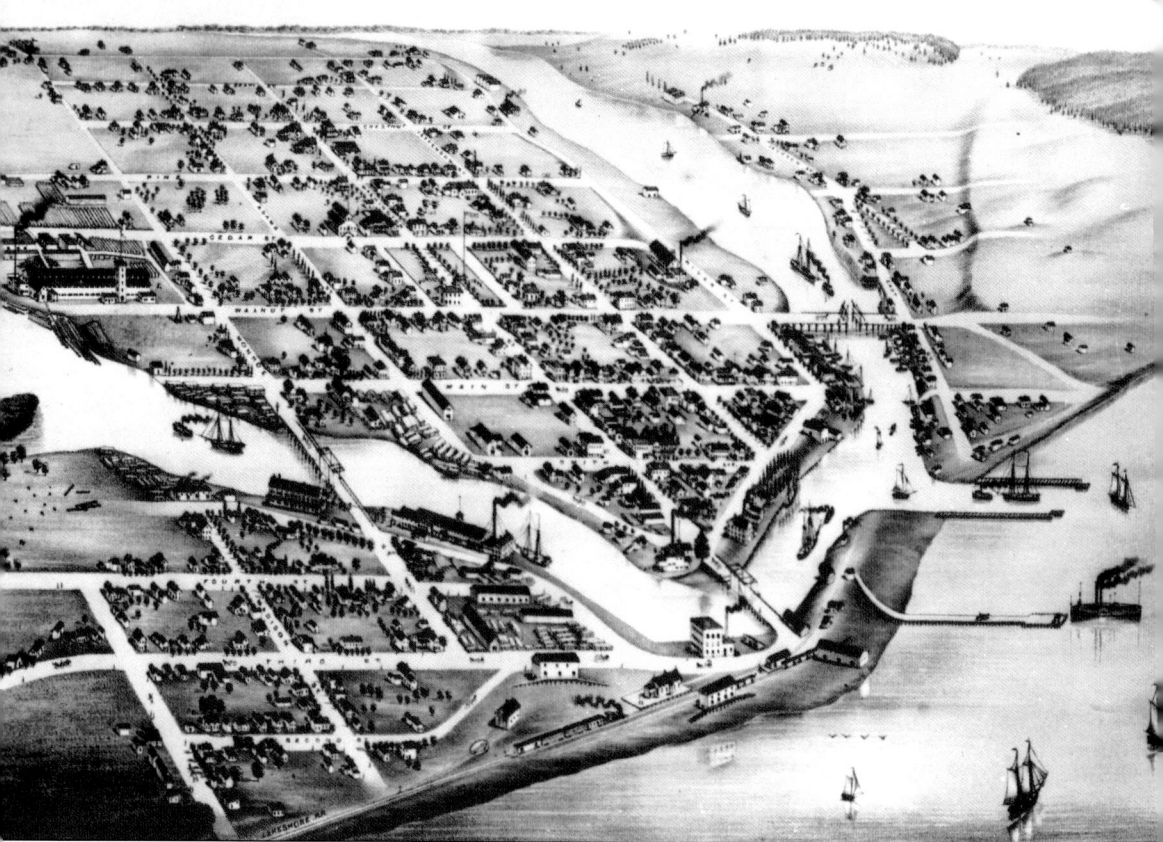

Henry Wellge and J. Bach of Milwaukee crafted this 1879 lithograph of the city of Two Rivers. (Courtesy of "Life and Industry in Two Rivers: Photos and Catalogs.")

ON THE COVER: The Civil War monument in the center of the 1700 block of Washington Street was dedicated on June 9, 1900. The local Grand Army of the Republic donated it. Two Rivers lost 25 men during the Civil War, including William Hess, who was killed at Gettysburg. The cover depicts the scene immediately after the dedication. The crowd, including horses and buggies, filled the street. People can be seen leaving the ceremonies. Nilles Furniture Store and St. Luke's Catholic Church are prominently visible to the north. (Courtesy of the Manitowoc County Historical Society.)

IMAGES of America
TWO RIVERS

Patrick J. Gagnon and Cassandra Gagnon Kronforst

Copyright © 2012 by Patrick J. Gagnon and Cassandra Gagnon Kronforst
ISBN 978-0-7385-8871-1

Published by Arcadia Publishing
Charleston, South Carolina

Printed in the United States of America

Library of Congress Control Number: 2011938600

For all general information, please contact Arcadia Publishing:
Telephone 843-853-2070
Fax 843-853-0044
E-mail sales@arcadiapublishing.com
For customer service and orders:
Toll-Free 1-888-313-2665

Visit us on the Internet at www.arcadiapublishing.com

This book is dedicated to Rose Marek Gagnon, mother and grandmother, for guiding and inspiring generations of her family. We can never thank you enough for everything you have done and all you have given.

Contents

Acknowledgments		6
Introduction		7
1.	Time Was . . .	9
2.	Waterways and Lifeblood	21
3.	A Blue-Collar Community	43
4.	Commerce and Prosperity	55
5.	Progressive Citizenship	75
6.	Learning on the Lakeshore	91
7.	Places of Worship, Communities of Faith	99
8.	Rest and Relaxation in the Cool City	105

Acknowledgments

This book owes its existence to the kindness and expertise of many people who supported us throughout the research and writing processes. Access to images for the book was facilitated by Jeff Dawson and Chris Hamburg of the Lester Public Library, Mike Maher and Nick Spencer of the Manitowoc County Historical Society, James VanLanen of the Two Rivers Historical Society, Two Rivers city manager Greg Buckley, retired Two Rivers chief of police Randy Ammerman, and William Glandt, who shared photographs from his personal collection. Jeff Dawson allowed us to use his original photographs. Michael Wolfert of the information technology staff at Silver Lake College provided invaluable assistance with the scanning of images. Robert Fay, acknowledged Two Rivers historian, provided factual verification of textual material. Respected and esteemed Silver Lake College colleagues Suzanne Lawrence and Linda Briggs-Dineen, superb editors, provided a final stylistic assessment of the text. Finally, thank you to Jeff Ruetsche of Arcadia Publishing for initially proposing this project and to Arcadia's Chris Metcalf and Winnie Rodgers for their editorial guidance in bringing the book to fruition.

INTRODUCTION

> Where music of pines blends with the roar of the lake,
> And foam crested billows on roughened sands break;
> Where suns rise in splendor on Michigan's breast
> And sink in the glory of bright skies to rest;
> Home, home, there's my home
> Neshotah, my heart's-love, wherever I roam.
> —John Nelson Davidson

John Nelson Davidson only spent seven years in Two Rivers. He arrived in 1894 as the new minister of the Congregational church; his vocation led him to depart in 1901. Despite his brief period of residence, Davidson came to care enough about his adopted home to memorialize it in his "Ode to Two Rivers."

History is made up of patterns and rhythms that occur over time. Within the patterns and rhythms are found continuity and change, similarity and difference. Through a series of historic photographs, this volume seeks to communicate some sense of the patterns and rhythms, continuity and changes, that characterize the history of Two Rivers, Wisconsin. The photographs date from the 1850s, the initial years of Euro-American settlement, through 1970.

No one knows exactly when people first discovered the twin rivers on the western shore of Lake Michigan, located at 44 degrees, 9 minutes north latitude. Potawatomi and Menominee people were living in the area at the time of European contact. They named the place Ne-sho-tah, or "twins." Centuries before the arrival of Europeans, tribal fishers paddled birch bark and dugout canoes down the rivers and into the lake seeking whitefish and trout. They established a village where Two Rivers is now located.

After Jean Nicolet reached L'Baye (Green Bay) in 1634, several French explorers, including Pere Jacques Marquette, passed the mouth of the twin rivers on their journeys along the Lake Michigan coastline. The first record of European residency at Two Rivers appears in a 1779 entry in the log of the British sloop *Felicity*. At that time, a certain trader named Fay was reported to be established at the twin rivers.

Today's state of Wisconsin was a part of Michigan Territory in the 1830s. There were few American residents, and the land was government owned. As late as 1832, Joshua I. Boyd was granted a government license as a fur trader in the Two Rivers area. Change occurred quickly when Pres. Andrew Jackson opened the area for land purchases on May 6, 1835. Within months, land claims were filed for all of the land that would eventually become Two Rivers. John Lawe, one of the claimants, immediately established a sawmill and began shipping cut lumber from the area.

American and European population grew quickly, surpassing 900 by 1850. Two Rivers was then second only to Manitowoc Rapids in population among Manitowoc County settlements. Two Rivers continued to grow, though more slowly than Manitowoc, its neighbor to the south.

Two Rivers's population exceeded 2,000 by 1880. Population growth was rapid around the turn of the 20th century, and by 1910, the city had almost 5,000 people. The number of people grew by over 25 percent during each decade from the 1880s through the 1920s. The peak of growth was reached in the decade between 1910 and 1920 when the population increased by more than 50 percent. Hard times limited growth during the 1930s. On the eve of World War II, Two Rivers's population stood at 10,308. Two Rivers reached its peak in population and prosperity during a renewed period of growth in the 1950s and 1960s, the last decades represented in this volume. In 1970, the city's population stood at 13,553, the highest ever recorded by the decennial federal census. Since 1970, Two Rivers has experienced a slow decline in population.

The population of Two Rivers grew to embrace a distinctive blend of ethnicities. The first American settlers were New England Yankees who came to build sawmills and factories to exploit timber resources. A population of French Canadians quickly joined them. Dissatisfied with political and economic opportunity in Canada, they were recruited to establish a commercial fishery on Lake Michigan. German immigrants were also early settlers in Two Rivers. In the closing decades of the 19th century, a sizable Polish component was added to the community along with a smaller group of Bohemians. Later population growth saw numerous other ethnicities become represented in the community, but none grew to be a definitive element. At the end of the 20th century, Two Rivers was a city where the largest ethnic component was German, followed by Polish. French Canadians continued to add a permanently distinctive element to the Two Rivers ethnic mix.

Over the years, Two Rivers exhibited patterns typical of small American towns. From diverse early economic endeavors, Two Rivers emerged as an industrial city. Timber resources that first drew entrepreneurs to the area provided the basis for Two Rivers's growth into a manufacturing center for chairs, tables, and additional wood products. Commerce grew to support industry and to market goods to a working-class population. Community and culture, reflected in churches, schools, and other local institutions, accompanied the advance of prosperity. As American industrial dominance in the world receded, Two Rivers, like so many US cities, experienced slower growth and eventually lost some previous prosperity. Development shifted toward tourism and a service-oriented economy.

While Two Rivers followed typical American patterns, there is much in its history that makes it distinct from other cities: the ice cream sundae was invented; wood type was first manufactured; a cache of snow was found intact in the middle of July; and the city became known as "Carptown." But what gives Two Rivers its greatest distinction is its relationship with the rivers and the lake. These waters supported the long-standing and significant presence of commercial fishing in the local economy. Lake Michigan provided the community with the lasting treasure of an unbroken sand beach waterfront on its east side. Unique geography, combining the effect of Lake Michigan with the locale of a small peninsula, created a distinct climate, especially during the summer. Two Rivers is "the Coolest Spot in Wisconsin."

Two Rivers has a rich photographic history. Finding appropriate pictures for this volume was not a challenge; the challenge was deciding which photographs to omit. Lester Public Library in Two Rivers, the Two Rivers Historical Society, and the Manitowoc County Historical Society have significant collections of historic Two Rivers photographs. Hubert R. Wentorf (1894–1980), a Two Rivers photographer, kept a large archive of his own work and collected the work of other photographers. The Wentorf Collection at Lester Public Library forms the core of the digitized "Life and Industry in Two Rivers: Photos and Catalogs" collection available online, which provided the core set of images for this book. Readers seeking historic images of Two Rivers beyond those contained in this volume would do well to visit the Lester Public Library website (www.lesterlibrary.org) and explore the photographic collections at the Two Rivers Historical Society and the Manitowoc County Historical Society.

It is our hope that the photographs presented here give a sense of the patterns and rhythms of Two Rivers life that will revive old memories for some and enlighten others.

One

TIME WAS . . .

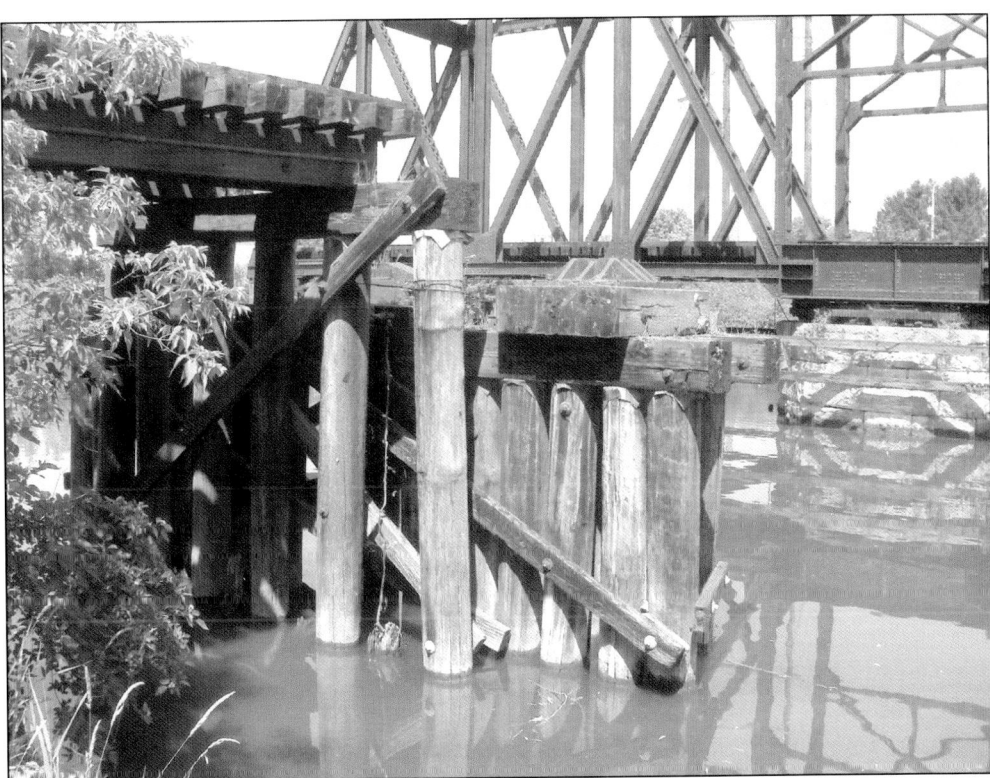

In 1837, there were only 40 white people living at Two Rivers. In 1849, local Indians still met for festivals in the area of Seventeenth and East Park Streets. By 1890, Two Rivers was integrating itself into the rhythms of late-19th-century American small-town life. This chapter presents images from the years prior to 1890. Pictured is the West Twin River railroad bridge. (Photograph by Cassandra Gagnon Kronforst.)

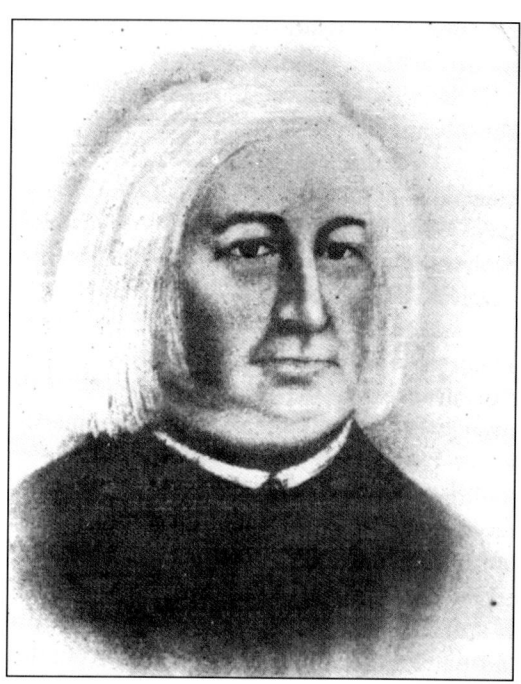

In 1836, John Lawe and his partners Robert M. Eberts and John Arndt were among the first Two Rivers land claimants, purchasing 320 acres of government land. Lawe, who was once a fur trader, and his partners erected a sawmill near the junction of the two rivers. A Green Bay resident, Lawe was influential throughout eastern Wisconsin. He died in 1846. (Photograph from Louis Falge, *History of Manitowoc County, Wisconsin*.)

Main (Sixteenth) Street was Two Rivers's primary business corridor during the 19th century, especially this block between Jefferson and Washington Streets. This photograph was just months removed from the winter of 1881, one of the worst in history. No mail reached Manitowoc for nine consecutive days, and severe cold prompted the *Manitowoc County Chronicle* editor to accept wood in lieu of cash for subscription payments. (Courtesy of the Manitowoc County Historical Society.)

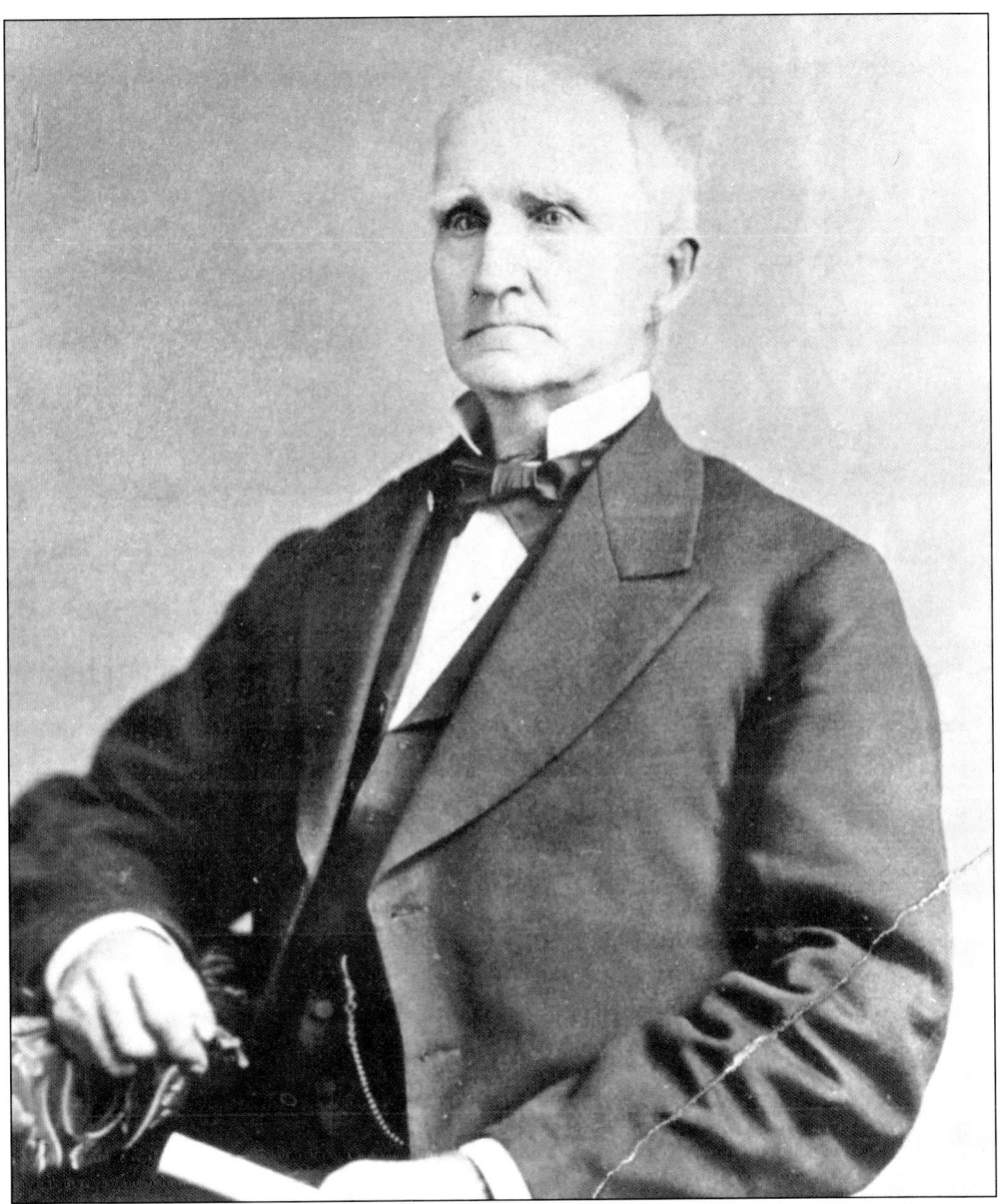

Hezekiah Huntington "Deacon" Smith is usually regarded as "the Father of Two Rivers." Born in 1798 in Windham, Connecticut, Smith was the grandson of a Revolutionary War officer. Arriving in Two Rivers in 1845, he owned the Lawe sawmill that provided the early basis for community prosperity, industry, and settlement. Over almost 40 years, Smith was associated in either an ownership or management capacity with all of Two Rivers's woodenware manufacturing concerns. Smith was a religious and educational leader and a legal and medical authority in early Two Rivers. He was known as "Deacon" because he filled the pulpit of the Congregationalist church when the community lacked an ordained minister. Smith's grandson was J.E. Hamilton, inventor of wooden printing type and founder of the Hamilton Manufacturing Company. In 1883, Deacon left Two Rivers for Grand Rapids, Michigan, where he died three years later at the age of 87. Others followed Smith from New England, and this influx of Yankee entrepreneurs helped to put Two Rivers on the map. (Courtesy of "Life and Industry in Two Rivers: Photos and Catalogs.")

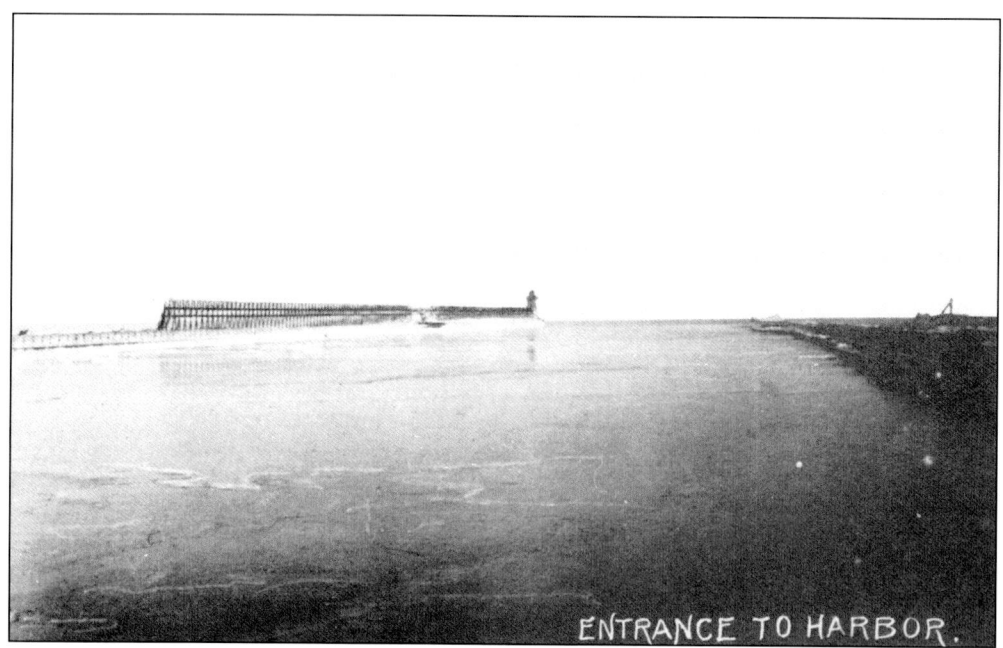

By 1890, the North Pier, its lighthouse, and elevated walkway had been built. Harbor improvements provided a dependable channel and facilitated shipping. Lake commerce was the lifeblood of port settlements like Two Rivers. Two Rivers's mackinaw fishing fleet, the largest on Lake Michigan in 1880, also passed through this harbor. Fishing was usually conducted within three or four miles of the mouth of the harbor. (Authors' collection.)

On July 16, 1851, St. Luke Parish was founded by Fr. Joseph Brunner, S.J. Robert M. Eberts, an original Two Rivers land claimant, donated land for a church to be built. Completed during the summer of 1853, the church was constructed using lumber from the surrounding trees. When built at Jefferson and Pine (Nineteenth) Streets, the church stood at the edge of settlement. (Courtesy of St. Peter the Fisherman Parish.)

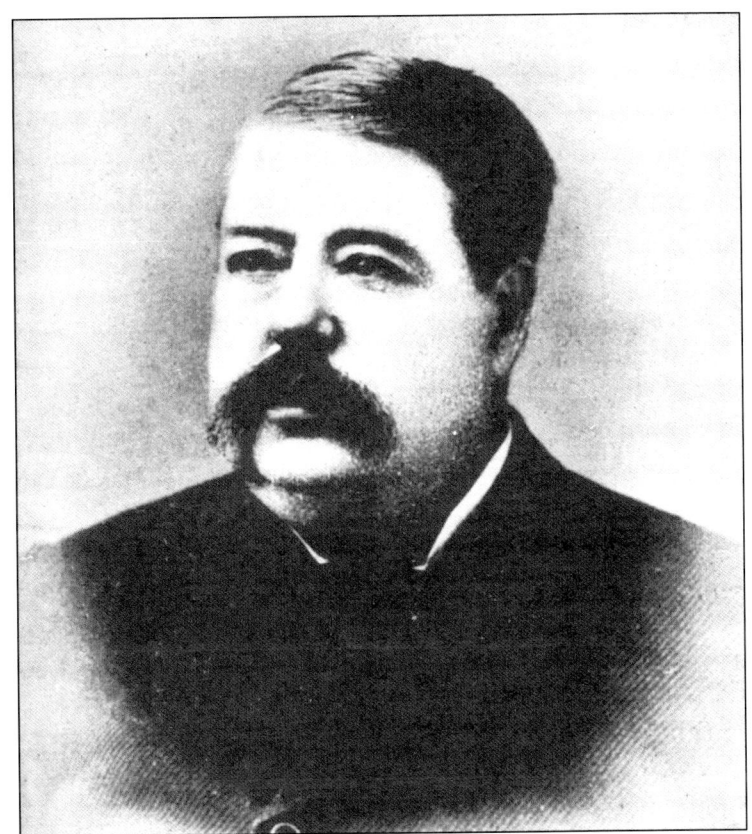

Henry S. Pierpont was typical of many early entrepreneurs and politicians—he was a business failure but a community success. His sawmill failed; he passed the bar but rarely practiced law; he founded the first newspaper, the *Manitowoc County Chronicle*, but soon sold it. Yet, in 1859, he was elected the second village president and later was county judge, clerk, and board member. (Photograph from *History of Manitowoc County, Wisconsin*, by Louis Falge.)

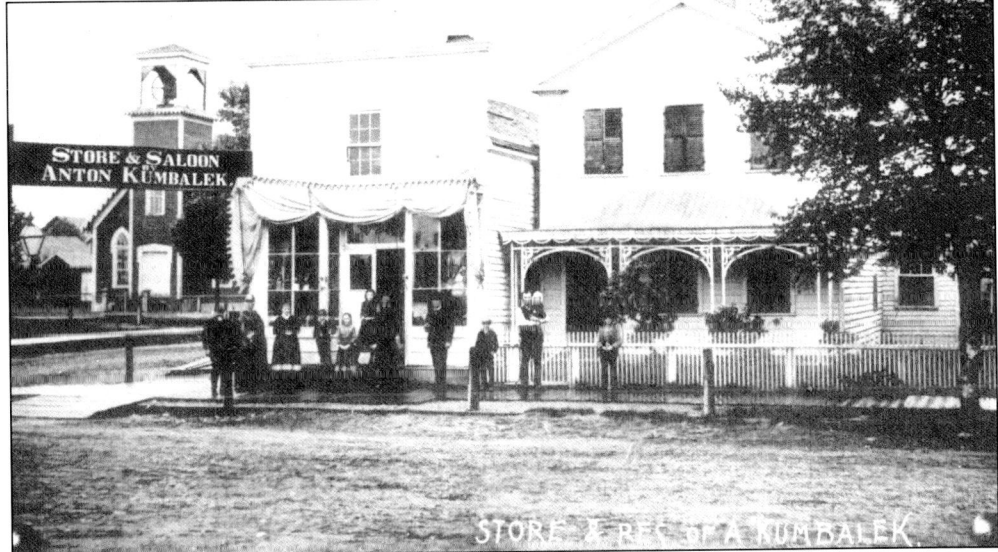

In the mid-1880s, Anton Kumbalek (1848–1907), far left, and his family assembled on the wooden sidewalk in front of Kumbalek's business on the southeast corner of Walnut (Seventeenth) and Washington Streets. A harness-maker by trade, Kumbalek sold assorted buggy accessories as well as operating a saloon and a boardinghouse. The old Lutheran church is visible to the east. (Courtesy of "Life and Industry in Two Rivers: Photos and Catalogs.")

One of Two Rivers's early leaders, William F. Nash purchased the *Manitowoc County Chronicle* from Henry S. Pierpont (page 13). Nash was editor-in-chief and publisher of the *Chronicle* from 1876 until his death in 1904. Nash was also a dedicated Democrat, at various times holding the titles of mayor of Two Rivers, state assemblyman, and state senator. (Courtesy of "Life and Industry in Two Rivers: Photos and Catalogs.")

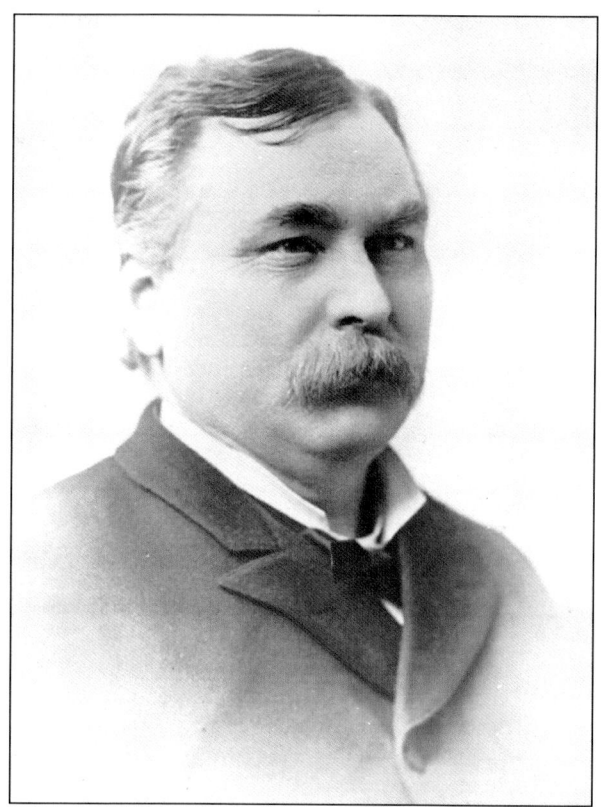

Henry Carter Hamilton, patriarch of the Two Rivers Hamilton family, was born in 1827. He arrived in Two Rivers in 1849, engaged in various businesses, and served as the first village president. He married Diantha Smith, daughter of Hezekiah Smith, Two Rivers's leading citizen. After Union army service, Hamilton died in Tennessee in 1864 as a sutler, a civilian Army supplier. (Photograph from Louis Falge, *History of Manitowoc County, Wisconsin*.)

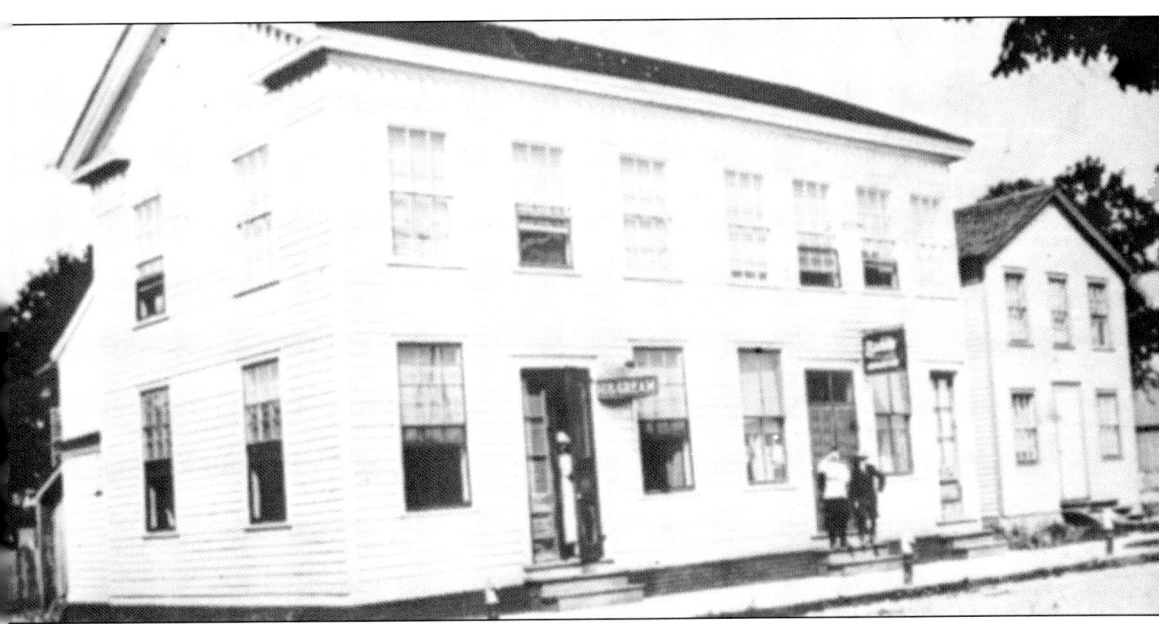

Everyone from Two Rivers knows that the city is the birthplace of the ice cream sundae. This is the building where the magic happened! On a Sunday in 1881, young George Hallauer asked Edward C. Berners, owner of the soda fountain on Smith Avenue, to put chocolate sauce used for ice cream sodas on the dish of ice cream he had ordered. The new treat gained immediate popularity but was sold only on Sundays. Then, one day a little girl convinced Berners to "pretend it was Sunday" and to sell her the concoction on a weekday. A glassware salesman used the name "sundae dishes" when he ordered the canoe-shaped dishes in which the ice cream was served, and Berners's innovation had its name. In 1973, an official Wisconsin Historical Marker was placed in Central Park commemorating Two Rivers's unique role in American dessert history. Later, the address of this building was changed to 1404 Fifteenth Street. Berners's ice cream parlor was demolished in 1979. (Courtesy of "Life and Industry in Two Rivers: Photos and Catalogs.")

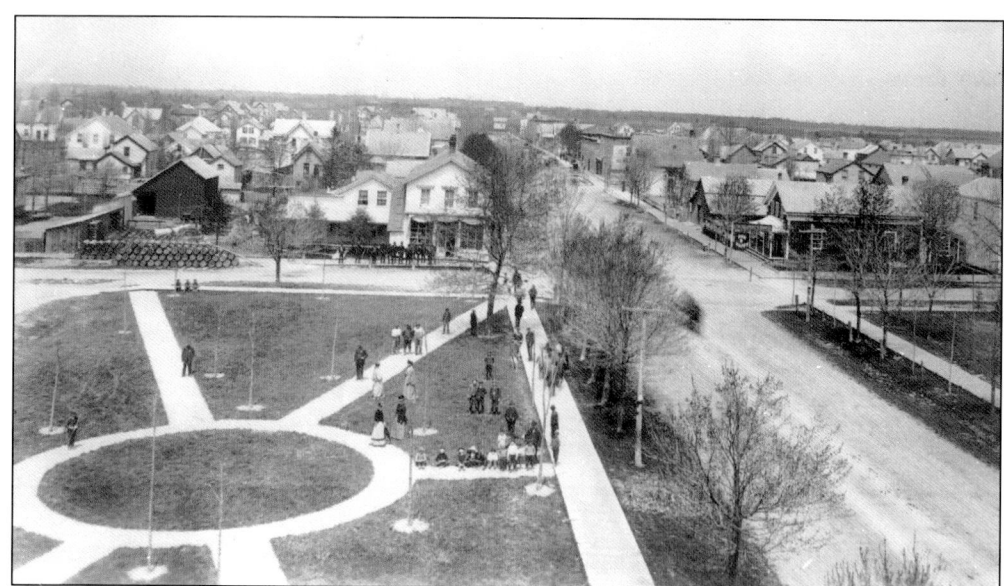

Henry Kappelman completed the design of Central Park in 1885. This is a view of the west half of Two Rivers's freshly built and planted park. The bandstand would later be constructed in the circular center plot. The original Schroeder Brothers' Store is visible in the center background at the intersection of Cedar (Eighteenth) and Washington Streets. (Courtesy of "Life and Industry in Two Rivers: Photos and Catalogs.")

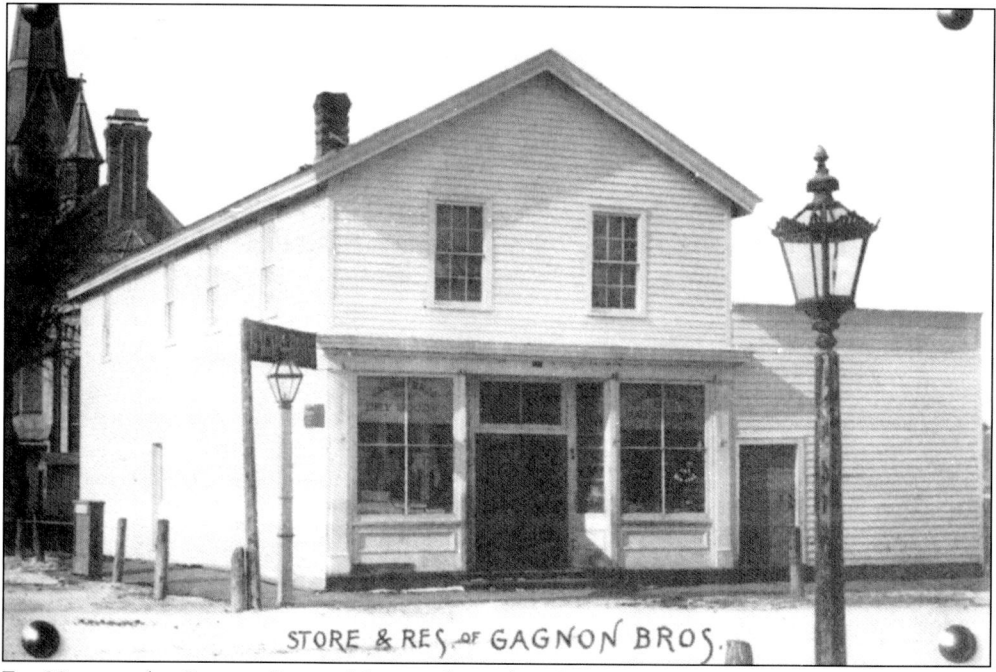

For 28 years, the Gagnon Bros. sold general merchandise, offered fish twine made to order, and sold insurance from this store on the northwest corner of Walnut (Seventeenth) and Jefferson Streets. Previously, Jonas Gagnon (1846–1915) and Peter Gagnon (1849–1917) were partners on the tug *Mary A. Gagnon*. In government, Jonas served a term in the state assembly, and Peter was mayor of Two Rivers, 1897–1900. (Authors' collection.)

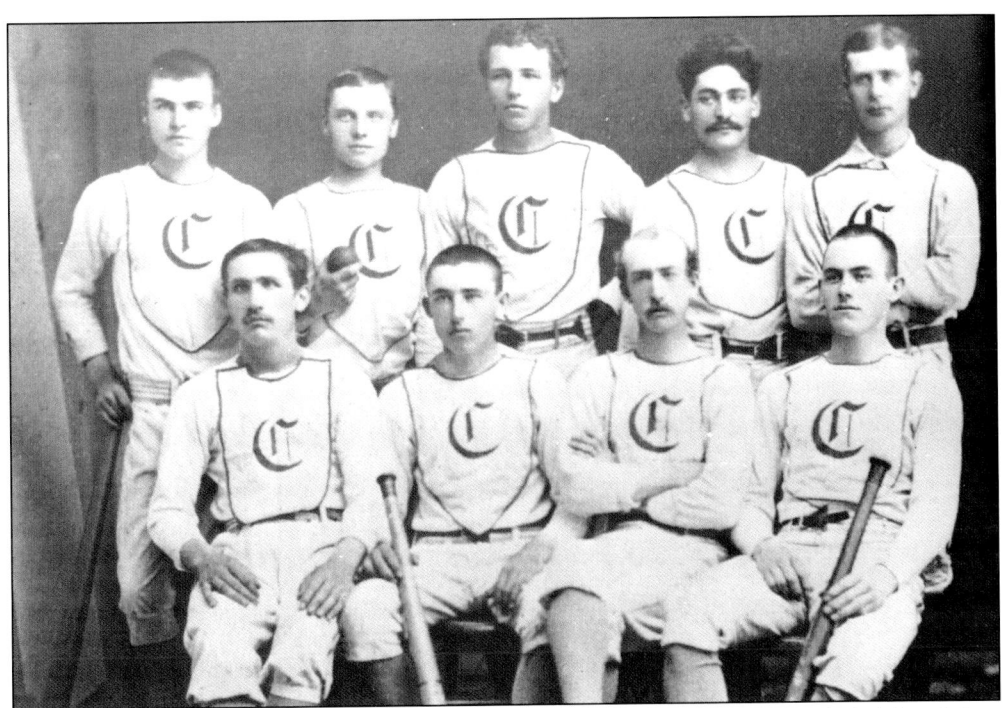

The 1874–1875 Centennials team was Two Rivers's first baseball club. Members included, from left to right, (first row) Fred Beth, Henry Walsh, J.E. Hamilton, and William P. Hayes; (second row) Thomas Walsh, Fred Schnorr (pitcher), Wencil Cisler, Max Fishbein, and Ed Charleston. One player, William Ahearn, was not present. (Courtesy of "Life and Industry in Two Rivers: Photos and Catalogs.")

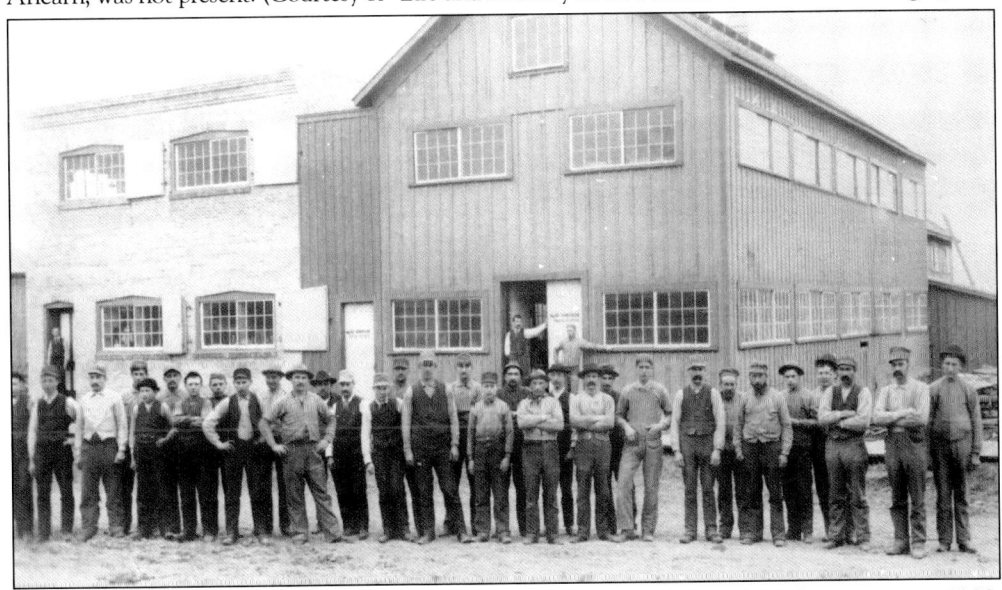

When J.E. Hamilton produced some custom-designed wood type for the local newspaper in 1880, his wood type business boomed. By 1887, he needed this unused sash and door factory, near the East Twin River, to manufacture type. Hamilton formed a partnership with its owner, William Baker. Within two years, Hamilton bought Baker out and incorporated his company. (Courtesy of "Life and Industry in Two Rivers: Photos and Catalogs.")

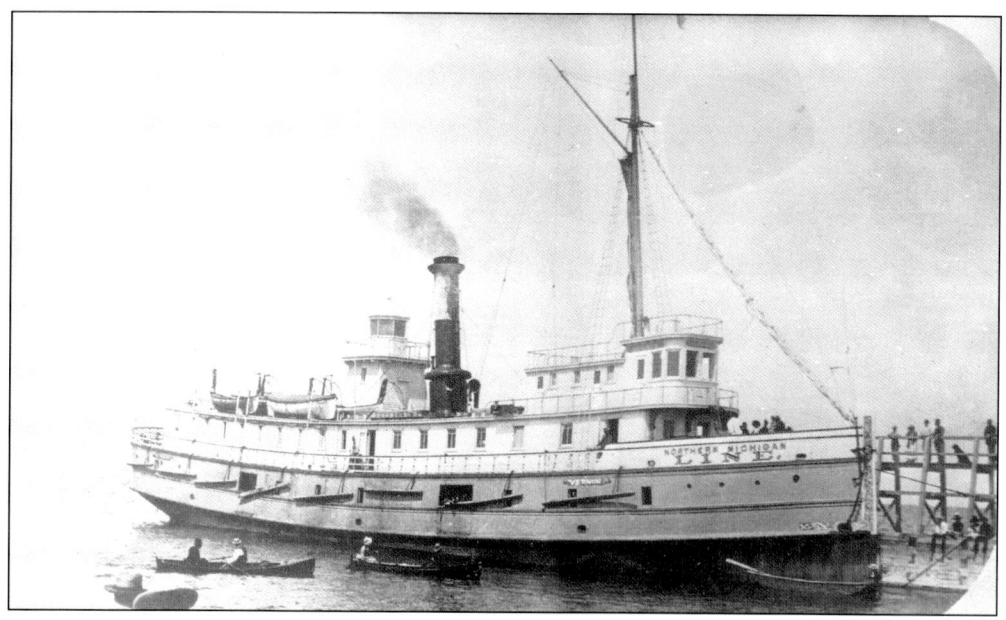

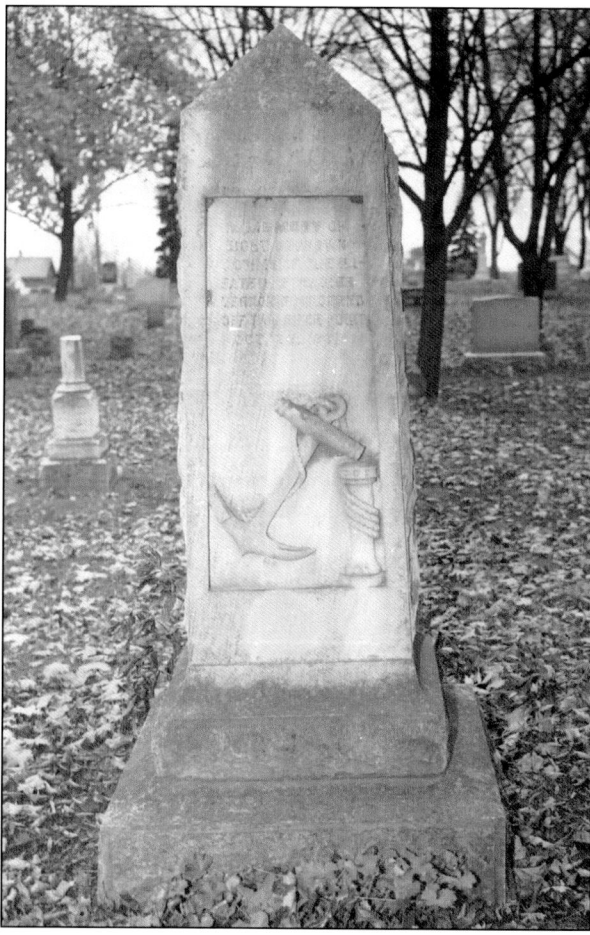

The steam ship *Vernon* of the Northern Michigan line was captained by George Thorpe. It was lost off of Two Rivers Point en route from Charlevoix, Michigan, to Chicago on Friday, October 28, 1887. The foundering was caused by a violent early-winter storm, well known by experienced mariners to be one of the deadliest circumstances to navigate on Lake Michigan. Thirty-one of 32 on board were lost. The bodies, recovered by fish tugs, were laid on the floor of the fire station at Walnut (Seventeenth) and Washington Streets for identification. A monument to the loss of the *Vernon* was erected at Pioneers Rest Cemetery and marks the grave of eight unidentified sailors who went down with their ship. (Both courtesy of "Life and Industry in Two Rivers: Photos and Catalogs.")

John Braun was a skilled jeweler who traveled the world in pursuit of perfection in his craft. This 1890 image shows his jewelry store, located on the west side of the 1600 block of Washington Street. Braun's hobby was photography, and his son Paul became a photographer by trade. John Braun also served as a city alderman. (Courtesy of "Life and Industry in Two Rivers: Photos and Catalogs.")

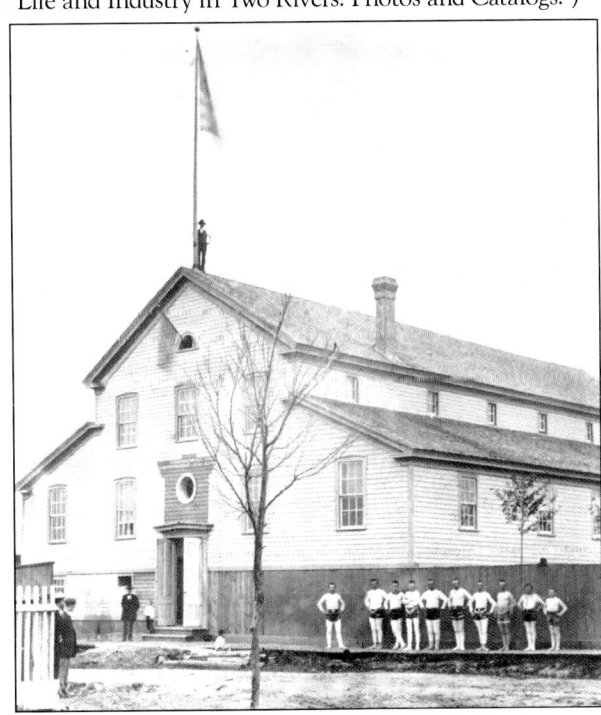

In the 19th century, any Wisconsin settlement with a sizable German contingent had a turnverein, a men's athletics and gymnastics club. Two Rivers's Turnverein was organized in 1857. Turner Hall, located in the block of Cedar (Eighteenth) Street between Washington and Adams Streets, was built in 1867. The Turners were humanists who believed in "sound mind in a sound body." (Courtesy of "Life and Industry in Two Rivers: Photos and Catalogs.")

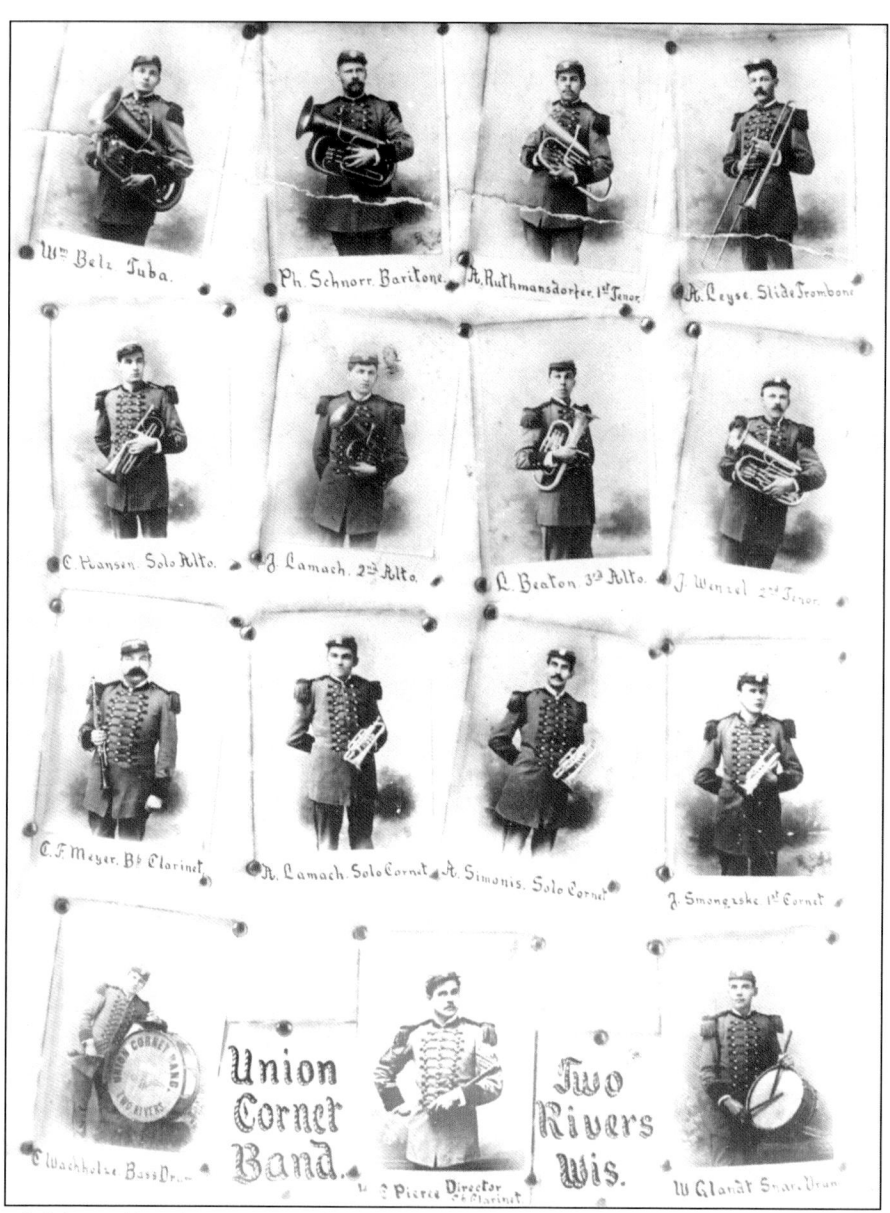

Musical clubs and bands were a popular pastime and social activity in small industrial towns, and Two Rivers was no exception. The coronet band was a popular type of brass band throughout the second half of the 19th century. Despite its seemingly formal structure, the band was available for weddings, birthday parties, and other celebrations. Many members of the Union Cornet Band participated in other bands and small orchestras. Members of the Two Rivers Union Coronet Band were, from left to right, beginning with the top row, William Belz (tuba), Phillip Schnorr (baritone), Alois Ruthmansdorfer (first tenor), and Albert Leyse (slide trombone); (second row) C. Hansen (solo alto), James Lamach (second alto), L. Beaton (third alto), and Joseph Wenzel (second tenor); (third row) Christian F. Meyer (B flat clarinet), Anton Lamach (solo cornet), Albert Simonis (solo cornet), and John Smongeski (first cornet); (fourth row) E. Wachholze (bass drum), E. Pierce (director and E flat clarinet), and Wilhelm Glandt (snare drum). (Courtesy of "Life and Industry in Two Rivers: Photos and Catalogs.")

Two

WATERWAYS AND LIFEBLOOD

Lakes, rivers, and the harbor were Two Rivers's lifeblood. The prospect of harvesting lake fish stimulated initial settlement, and local commercial fishing dates from 1837. John Pearson Clark (1808–1888) from Detroit established commercial fishing, bringing in a crew of 20 men who were primarily French Canadian. Whitefish and trout were the preferred quarry of early fishermen; when numbers of those species declined, herring, perch, and chubs were sought. (Authors' collection.)

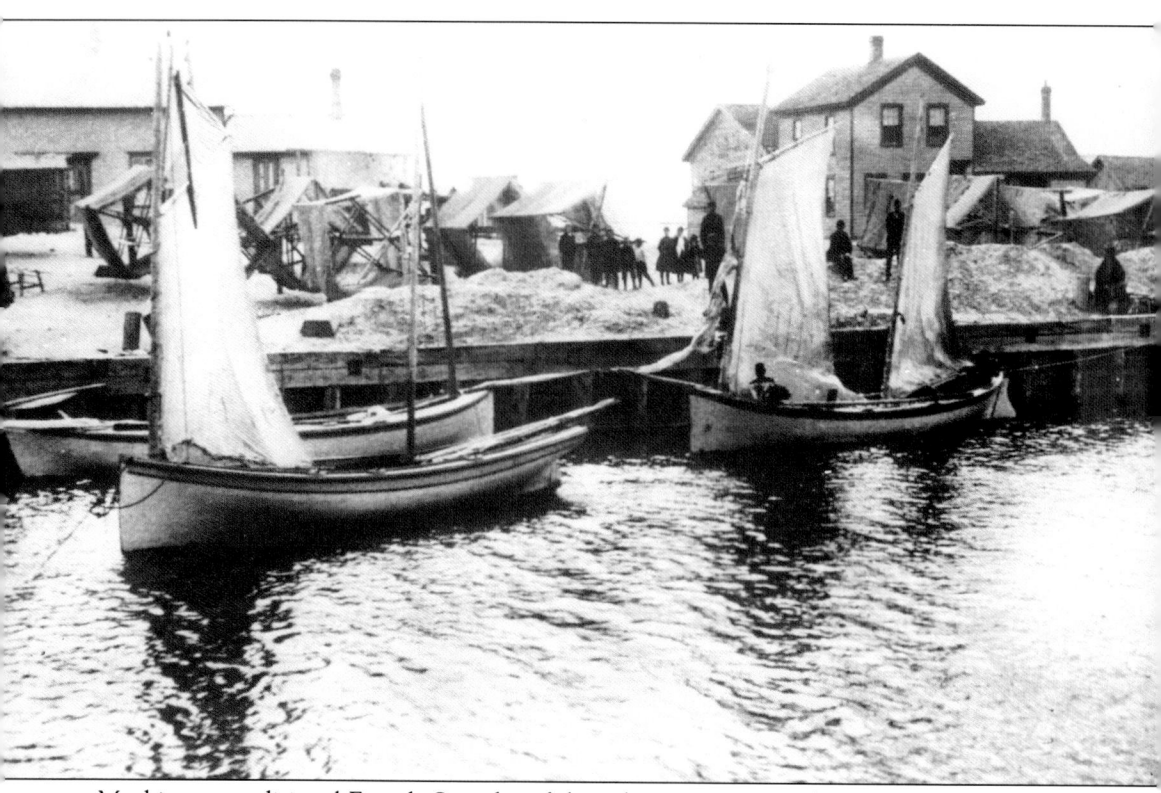

Mackinaws, traditional French Canadian fishing boats, were in wide use on the Great Lakes until the late 1890s. In Two Rivers, the first fishing boats were mackinaws. Typically, a mackinaw had an eight-foot beam, was 26 feet long, and four feet deep; most had two masts. Besides sails, the mackinaws were equipped with 18-foot oars to provide propulsion when there was no breeze. Mackinaws could accommodate two men, four boxes of gill nets, and a catch of fish. The boats performed well on rough waters, but those who fished with mackinaws needed to be skilled sailors to fully utilize Lake Michigan's winds and currents and to deal with the vicissitudes of lake weather. The danger of capsizing was real, and the drowning of mackinaw fishers did occur. By the early 20th century, the last mackinaws in Two Rivers were replaced by gasoline-powered fish tugs. Net reels, seen here, were used for drying nets. This picture was taken on April 8, 1891, at the Charles LeClair docks. (Courtesy of "Life and Industry in Two Rivers: Photos and Catalogs.")

This 1900 view of the Mishicot (East Twin) River looks south from west to east. The Walnut (Seventeenth) Street Bridge is prominent. Originally, fishing boats docked south of Walnut Street. Here, a couple of tugs, docked on the east bank, are visible. Primary docking for fish tugs moved north to the Rogers Street area by the 1920s. (Courtesy of the Manitowoc County Historical Society.)

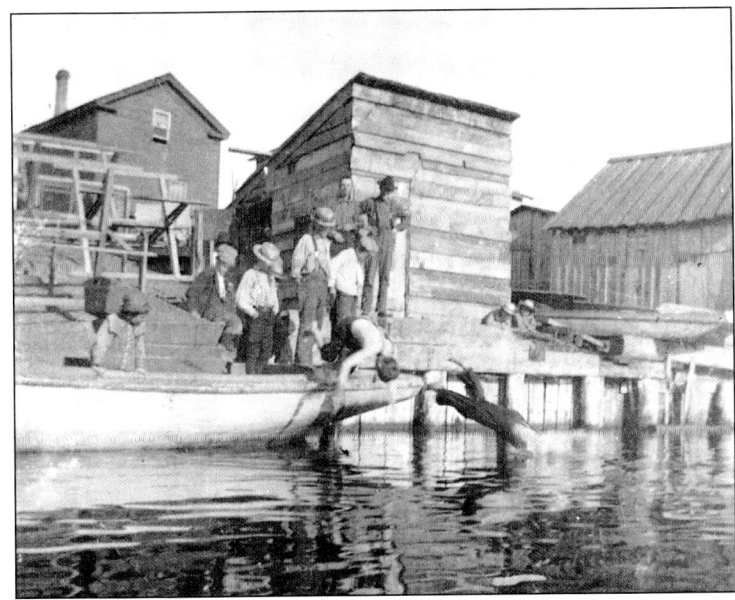

In this 1898 photograph, local boys cool off on a hot summer day with a plunge into the East Twin River. They dove from a mackinaw boat with a backdrop of fishing shanties and net drying reels. Prior to the advent of heavy industry and uncontrolled waste disposal, river swimming was popular in Two Rivers. (Courtesy of "Life and Industry in Two Rivers: Photos and Catalogs.")

23

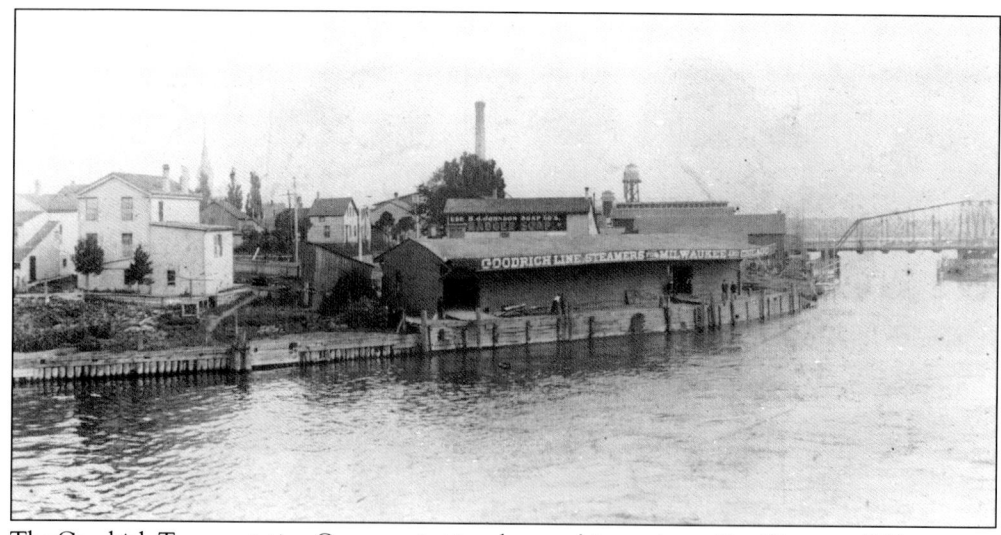

The Goodrich Transportation Company initiated steamship service to Two Rivers in 1855, running from Chicago to Sturgeon Bay with stops at ports in between. Several Goodrich vessels were sidewheelers. These docks were situated on the East Twin River inner harbor between Sixteenth and Seventeenth Streets. The old Walnut (Seventeenth) Street Bridge is visible in the background. (Courtesy of "Life and Industry in Two Rivers: Photos and Catalogs.")

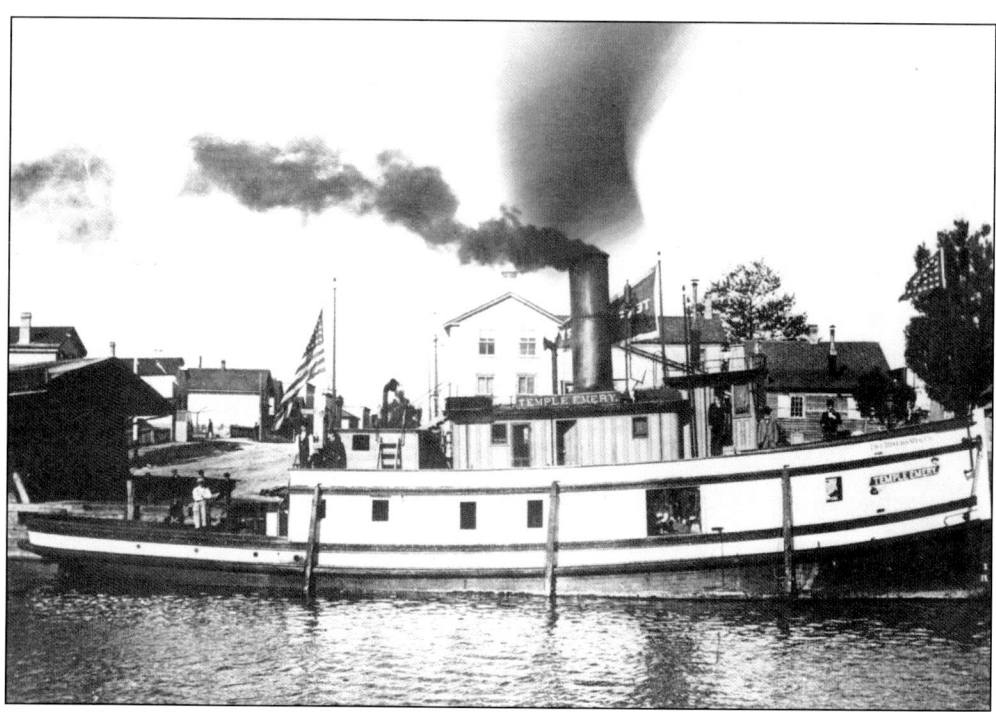

The tug *Temple Emery* was a dominant presence on the rivers. Built in Bay City, Michigan, in 1885 and used primarily to tug log rafts, it was owned and operated by the Two Rivers Manufacturing Company. Crewed by 11 men and large for a tug, it was 92 feet long, 22 feet at the beam, and 12 feet deep. (Courtesy of "Life and Industry in Two Rivers: Photos and Catalogs.")

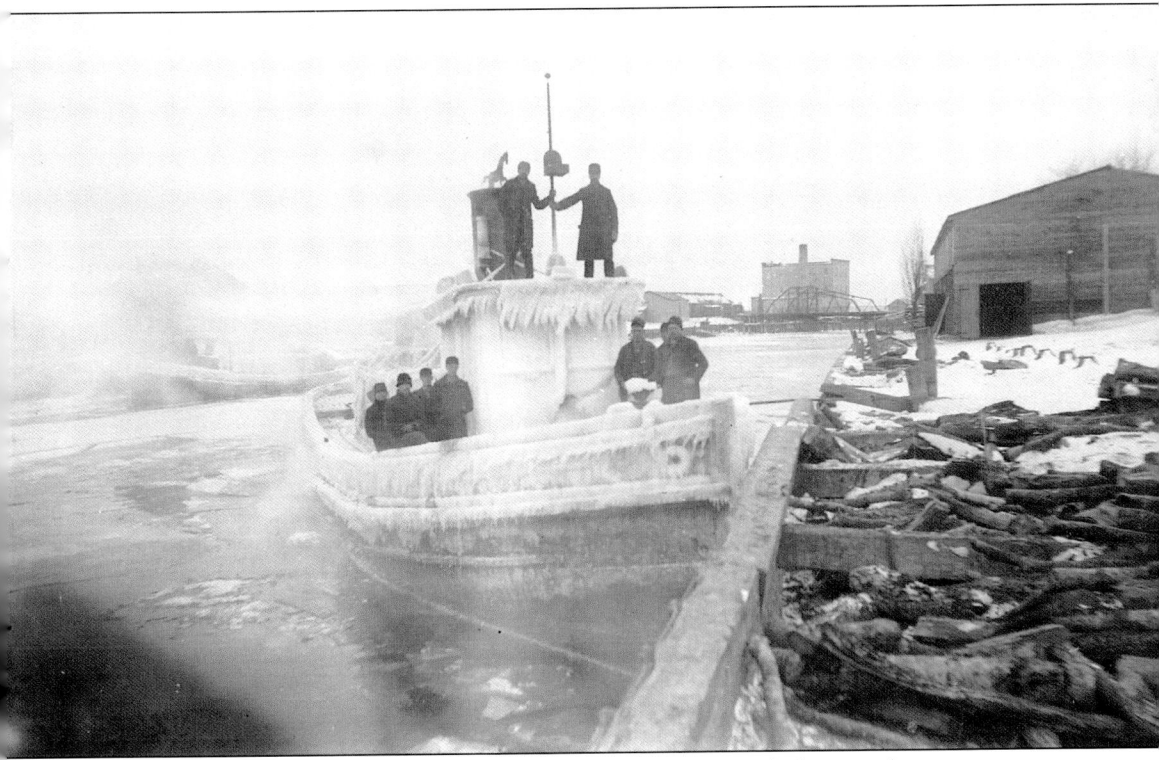

The following sea chanty was inscribed on the back of the original photograph:

"They fought the storm and wave.
The sturdy seamen brave.
Hurrah! Hurrah!
That was a noble fight.
One manly, just and right.
Hurrah! Hurrah!"
(Courtesy of the Manitowoc County
Historical Society.)

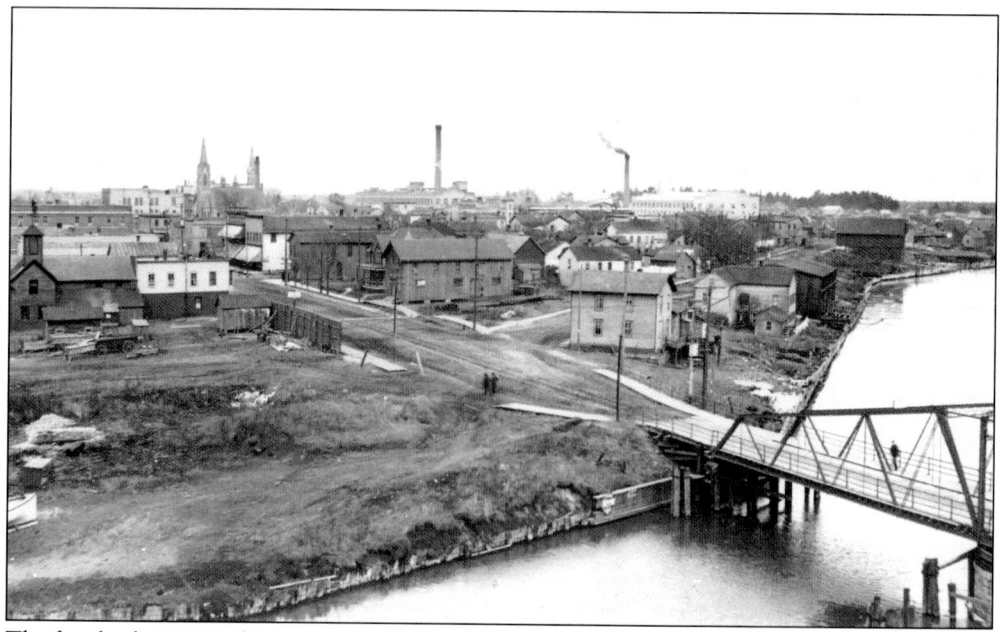

The first bridge on Washington Street was built in 1849. This 1906 photograph was taken looking northeast from the roof of the Wehausen Mill at the intersection of Washington and Twelfth Streets. This bridge, built in 1883, was Two Rivers's first steel bridge. It was a swing bridge, built by William Weinhagen, who submitted the low construction bid of $6,800. (Courtesy of "Life and Industry in Two Rivers: Photos and Catalogs.")

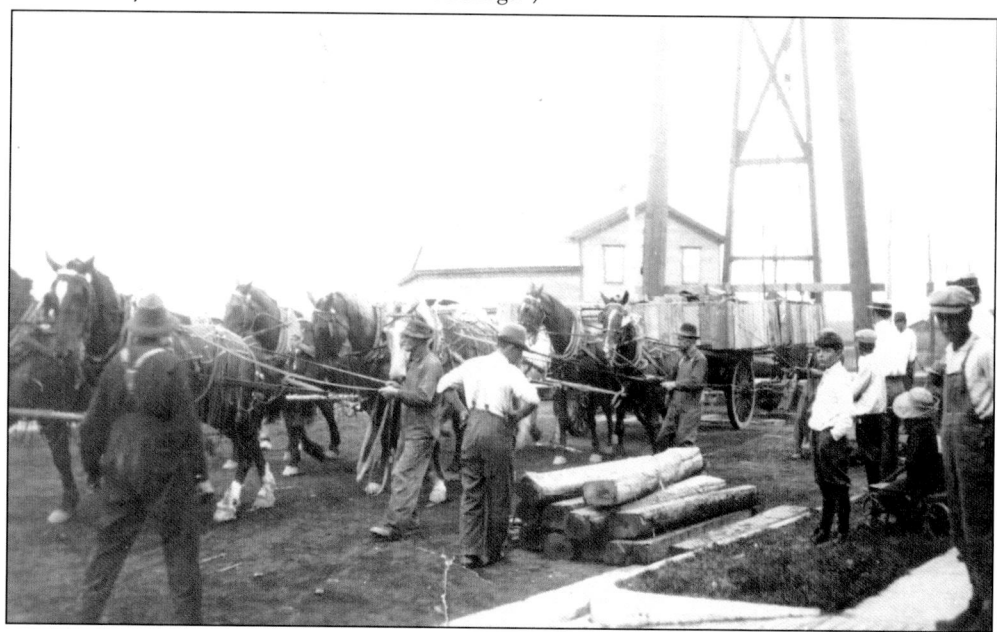

Repairs were underway on the north approach and planking of the Washington Street Bridge. Horsepower was used to drive piling. Coordination of three drivers and three teams was required. The driver of the first team was Henry Rau (1875–1923). The boy in knee-pants at the right was Rau's son Gerald (1904–1960), later a prominent lakeshore-area physician. (Courtesy of "Life and Industry in Two Rivers: Photos and Catalogs.")

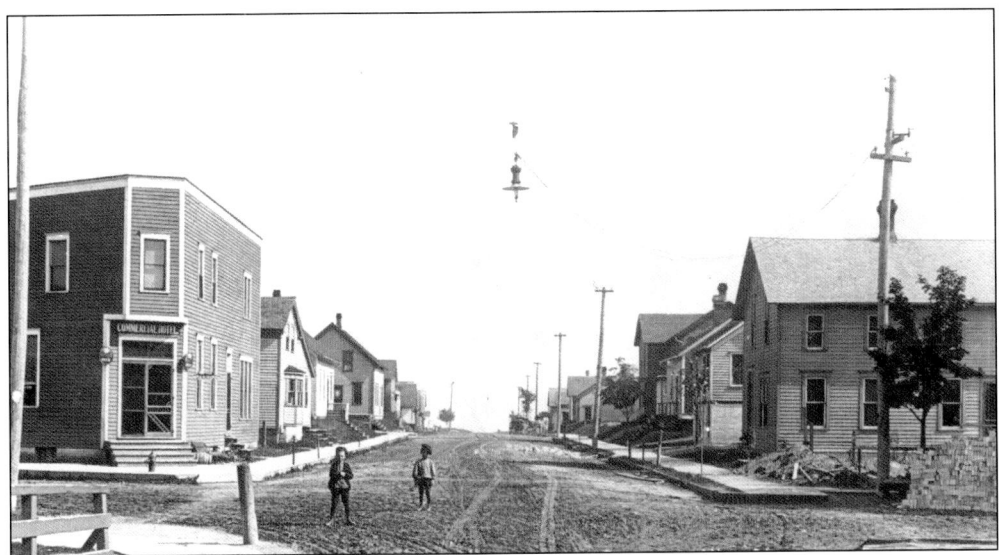

This photograph from about 1907 looks east down Walnut (Seventeenth) Street from the bridge. The building at left was the Commercial Hotel. Operating in the 1940s and 1950s as Claude Lodl's Oasis Tavern, it was nicknamed "Mayor Lodl's East Side City Hall." Note the unobstructed skyline along and at the end of the road, terminating at Lake Michigan. (Courtesy of "Life and Industry in Two Rivers: Photos and Catalogs.")

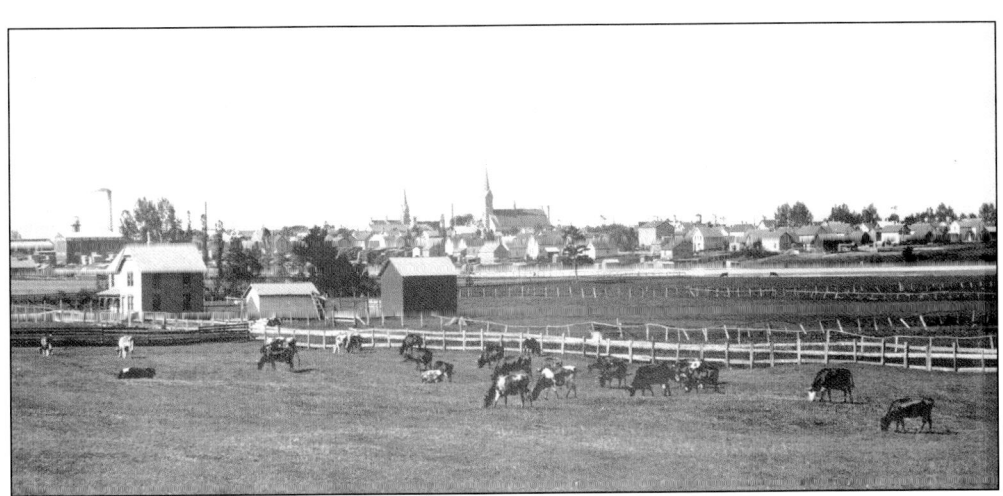

In 1893, east side development was limited and cattle still held domain. The foreground was later developed into Highway 42. The residence at left, owned by David LeClair, was later on Lincoln Avenue. This view was from Picnic Hill. That hill got its name because public school children held an annual June picnic at the approximate location of the old Two Rivers Hospital. (Courtesy of the Two Rivers Historical Society.)

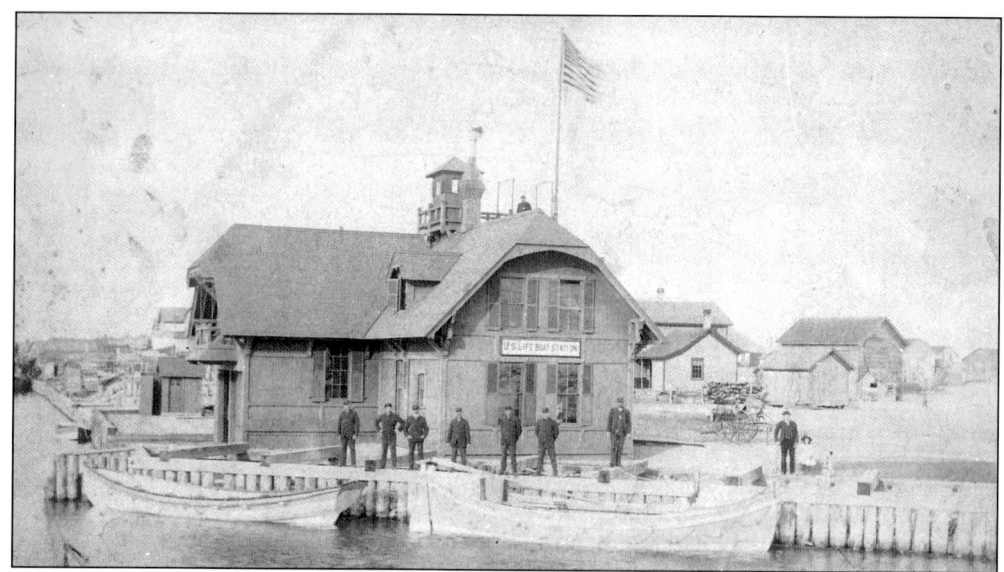

US Life Saving Service in Two Rivers was established in 1880. Oliver Pilon was the first keeper; he died of pneumonia contracted during a rescue. This station dates from 1876 and is representative of the clipped-gable style designed by architect Francis W. Chandler. When a new station was constructed, this building was purchased for a private home and moved to 724 Zlatnik Drive. (Authors' collection.)

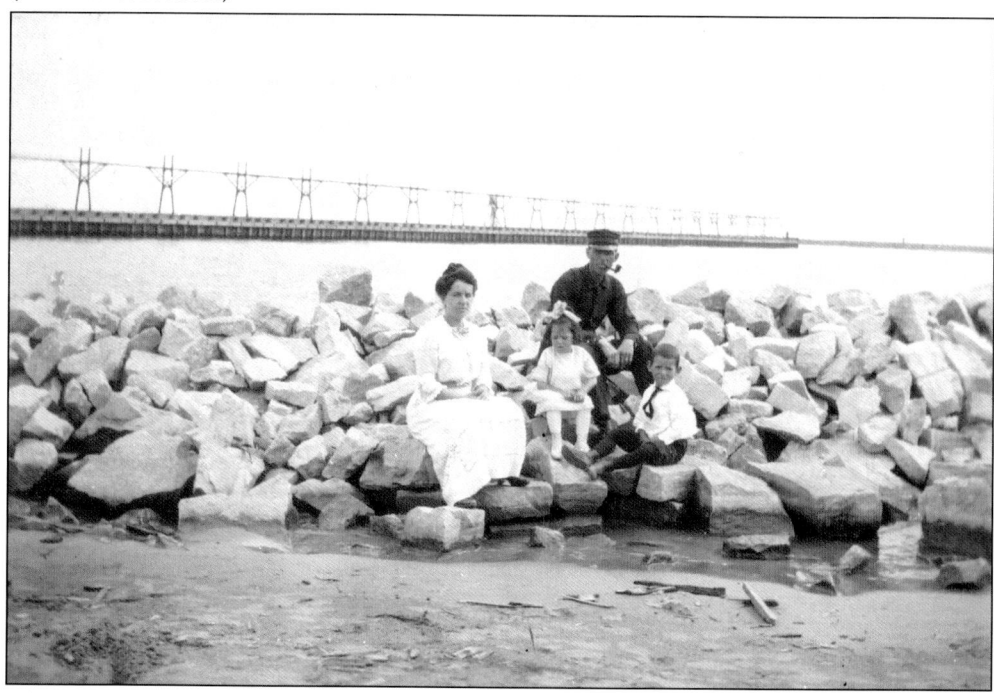

John S. Gagnon served with the US Life Saving Service from 1905 through 1916 in both Chicago and Two Rivers. One Sunday afternoon, Gagnon (1879–1954) posed with his family, Elmyra Allie (1881–1965), Aelred (1908–1978), and Beatrice Erdmann (1909–2001) near the Life Saving Station. In her 90s, Beatrice still recalled being terrified of the rocks and the water on the day that this picture was taken. (Authors' collection.)

The most famous shipwreck near Two Rivers was that of the *Rouse Simmons*, popularly known as "the Christmas Tree Ship." It sank with all hands during a particularly volatile Lake Michigan storm on November 23, 1912, bound from Michigan to Chicago with a cargo of Christmas trees. The *Rouse Simmons*'s anchor is on display at the Milwaukee Yacht Club. (Courtesy of "Life and Industry in Two Rivers: Photos and Catalogs.")

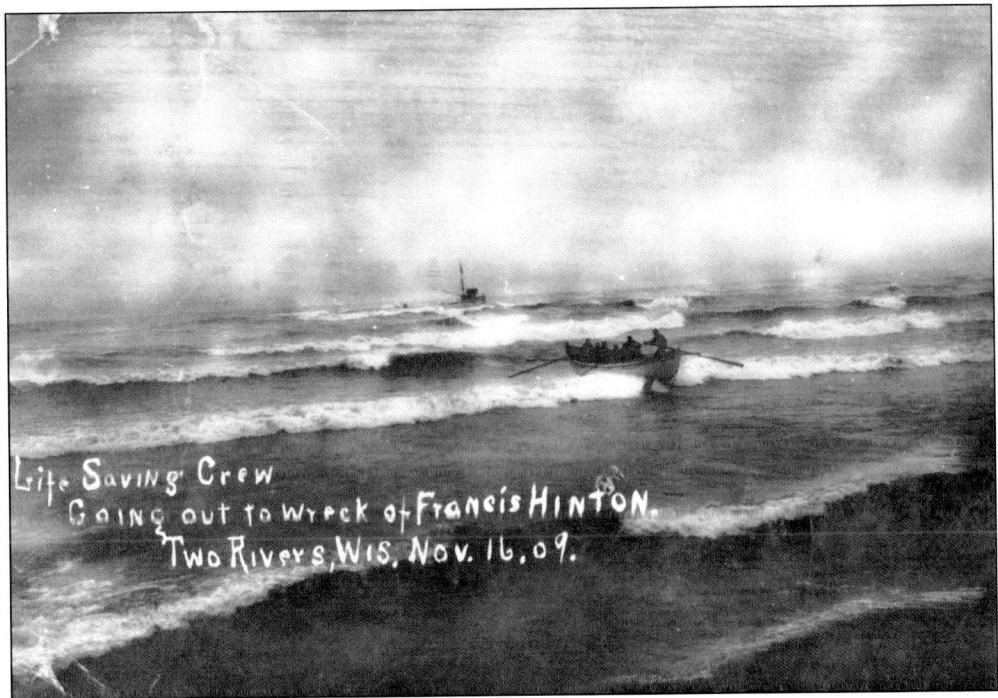

In 1909, the crew of the Two Rivers Life Saving Station launched its surfboat from the beach to reach the *Francis Hinton*, wrecked between Manitowoc and Two Rivers. They circled the wreck twice only to learn later that the crew of the *Hinton* had reached Manitowoc by lifeboat. The *Hinton* was built in 1889 at the Hansen-Scove Shipyards in Manitowoc. (Courtesy of the Manitowoc County Historical Society.)

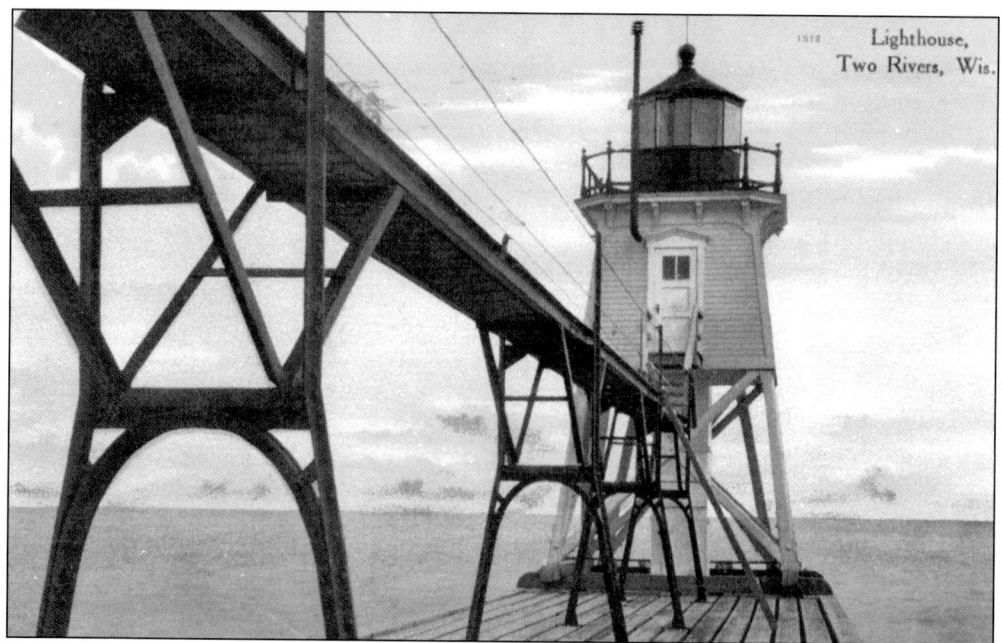

The North Pier Lighthouse went into service in 1886 when the pier was completed. The elevated walkway was used to reach the lighthouse during winter when ice and freezing spray made access over the concrete pier deck impossible. At the time of this photograph, approximately 1910, the North Pier Lighthouse was already a well-established Two Rivers landmark. The lighthouse served until 1972. (Courtesy of the Manitowoc County Historical Society.)

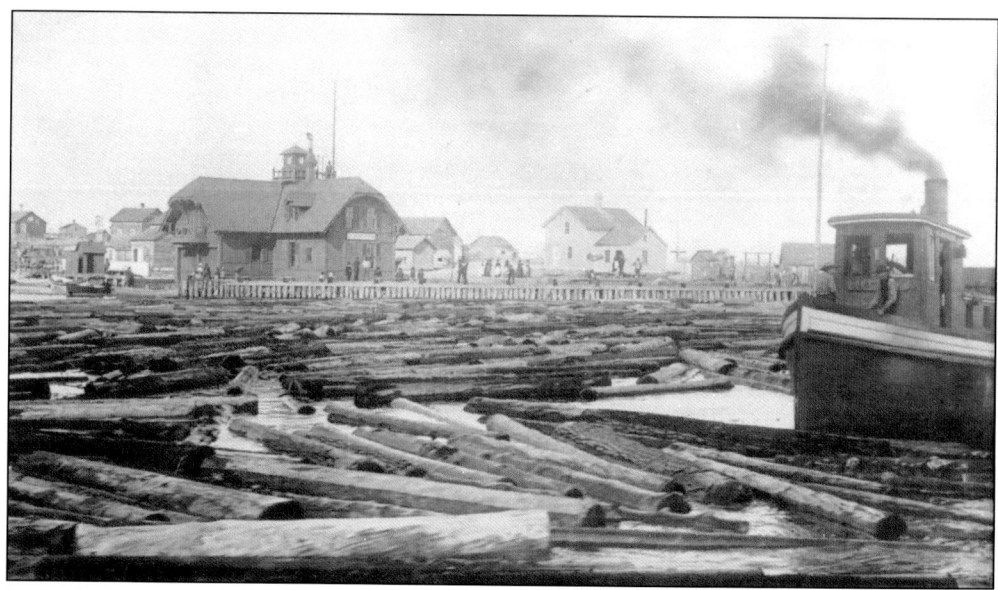

In 1895, when Two Rivers was a leading producer of woodenware, the harbor near the Life Saving Station was a literal logjam of timber. Life Saving Stations were staffed by a keeper and a crew of seasonally employed surfmen. The shipping season ran from April through November. In 1915, the Life Saving Service became part of the newly formed Coast Guard. (Courtesy of the Manitowoc County Historical Society.)

Nelson LeClair (1877–1966), left, and David LeClair (1871–1958) proudly posed with their Two Rivers Harbor record sturgeon around 1900. The beast was six feet, seven inches long, was 42 inches around at its largest point, and weighed 165 pounds. The two men stand in a rather uncommon pond net mackinaw boat. Typical fishing sheds are visible in the background. (Courtesy of "Life and Industry in Two Rivers: Photos and Catalogs.")

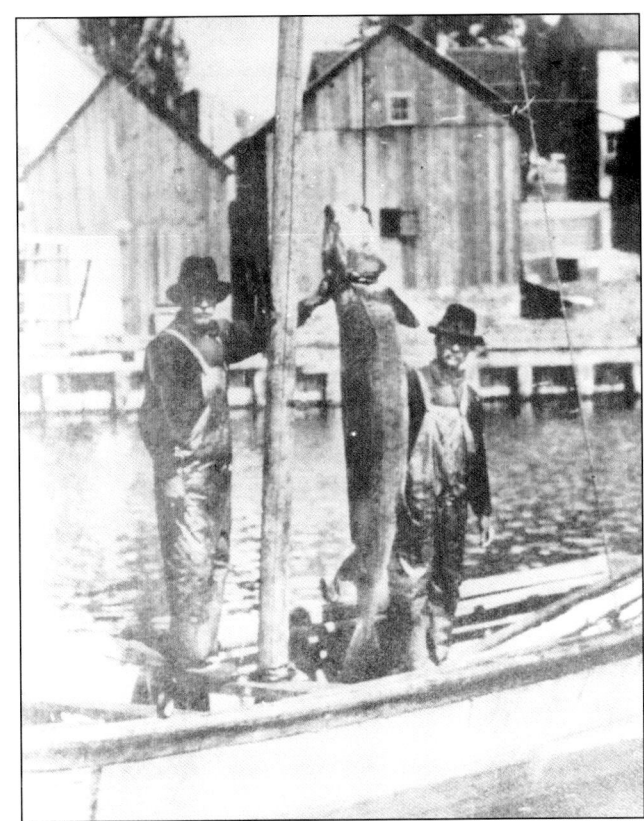

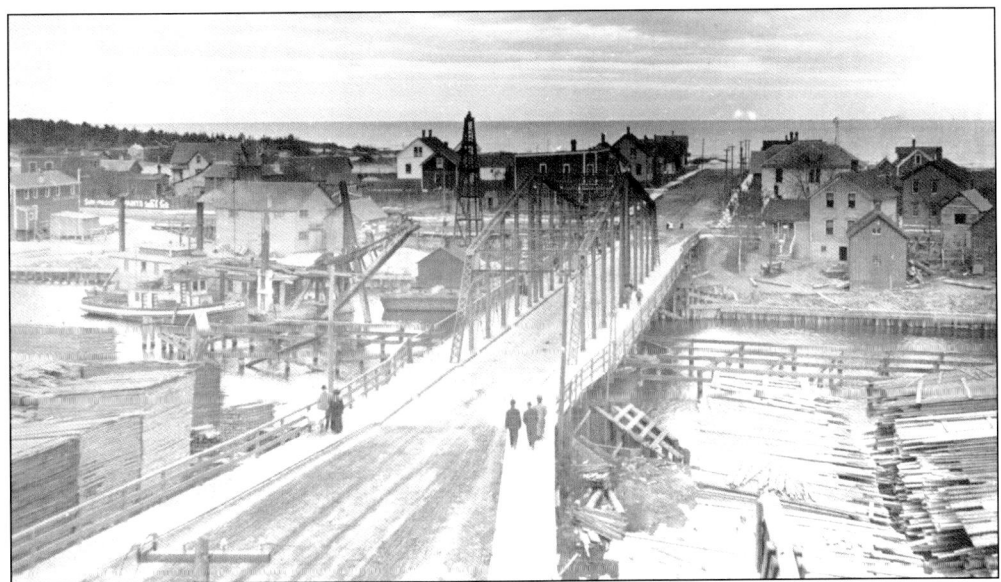

Walnut (Seventeenth) Street Bridge, seen in about 1915, was the last wooden bridge in Two Rivers. When built in 1894, it represented modern technology: a turntable bridge that allowed the roadway to turn parallel to the river for tall ships to pass. Note dredging equipment for deepening the channel, Hamilton Manufacturing Company lumber, and a spile driver moored on the east side. (Courtesy of the Two Rivers Historical Society.)

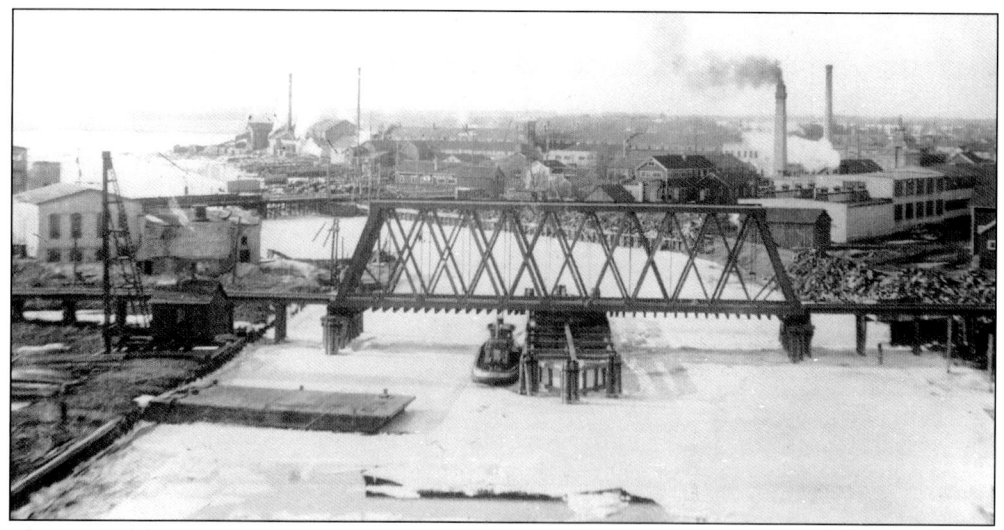

This view of the West Twin River during winter of 1910 shows the railroad bridge in closed position. Evident on the north side of the river, near the tracks, is a large quantity of logs that have been unloaded from railroad flat cars. The logs were sawed into lumber as well as being cut for pail and tub staves. (Courtesy of "Life and Industry in Two Rivers: Photos and Catalogs.")

When the Two Rivers fishing fleet assembled in the harbor for this 1934 photograph, most fishing was done with gill nets. Nets were set as a wall to catch fish by their gill covers as they swam through. Net bottoms were weighted with lead sinkers, and tops were kept afloat by wooden, then aluminum, floats. Net locations in the lake were marked by wooden buoys. (Authors' collection.)

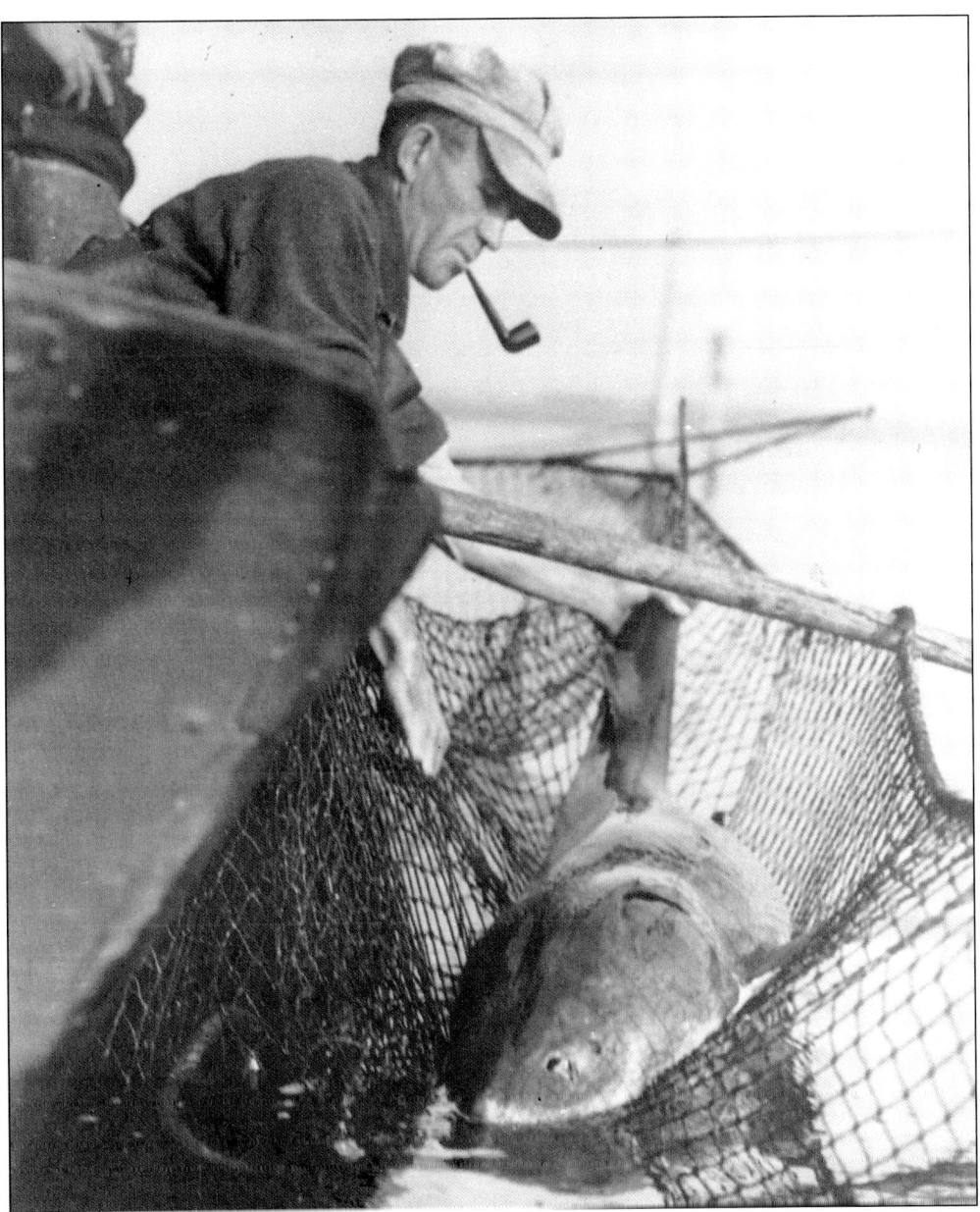

George LeClair (1890–1971) netted this six-foot sturgeon in Two Rivers in 1934. The LeClairs were one of Two Rivers's original fishing families and continue to fish the waters around the city to this day. George LeClair fished with pond (also called pound) nets. Pond nets were first introduced around 1860. Most pond net fishing took place north of Two Rivers Harbor. Pond nets were comprised of a system of three nets leading fish into a large net enclosure called the "pot." The pot was raised, and fish were alive when removed. This differed from the more common gill nets in which the fish were usually dead when the nets were raised. Pond nets were set on a series of spiles, long wooden poles that were driven into the lake bottom. Nets were repaired in place and often stayed in the water throughout the fishing season. Pond net fishing was discontinued shortly after 1950. In his later years, George LeClair was recognized as a commercial fishing authority. (Courtesy of "Life and Industry in Two Rivers: Photos and Catalogs.")

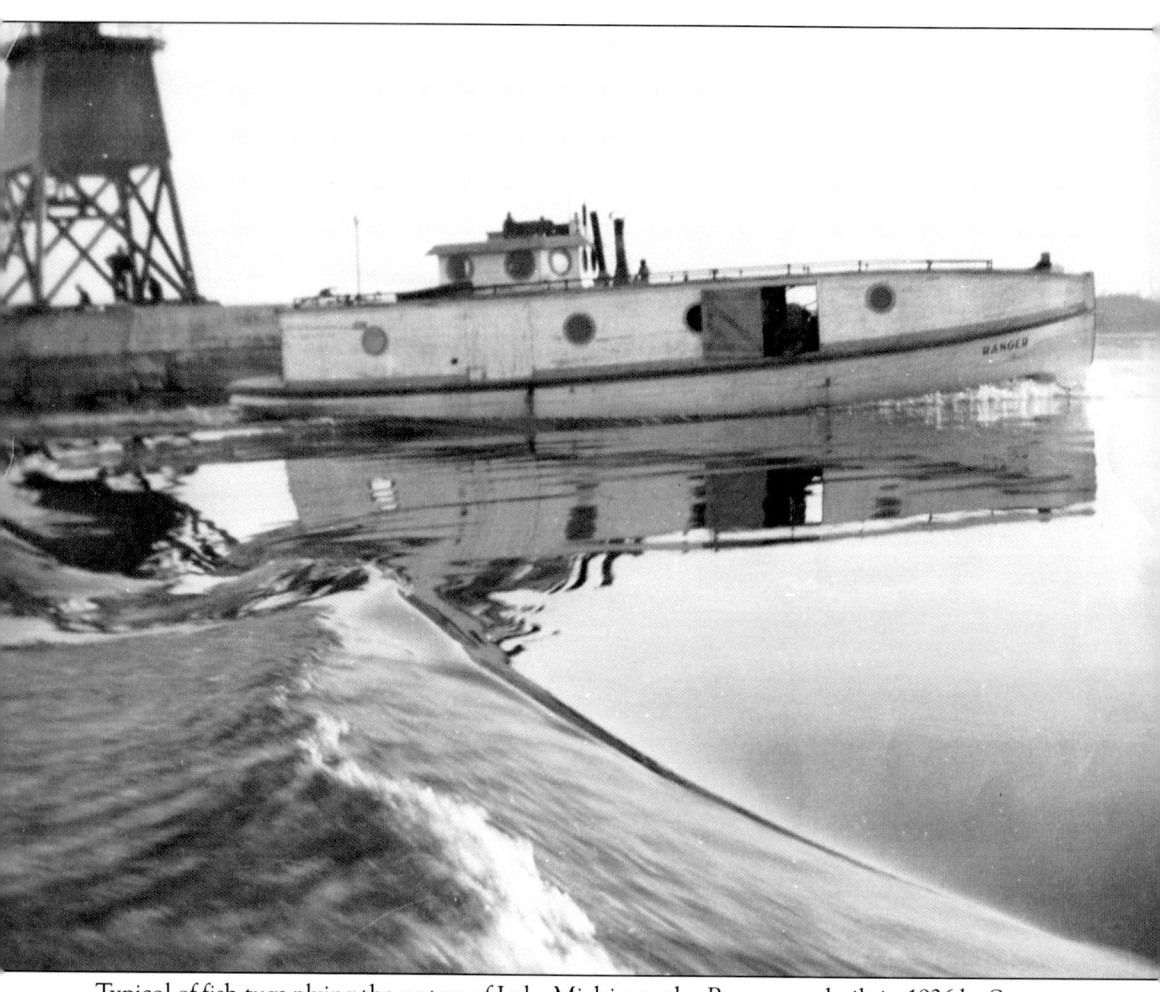

Typical of fish tugs plying the waters of Lake Michigan, the *Ranger* was built in 1936 by Sturgeon Bay Boat Works for Adolph Ruzek and William Westphal of Two Rivers. At 40 feet long and 12 feet wide, it had a two-cylinder Kahlenberg oil engine that generated 30–36 horsepower. Kahlenberg engines were the most popular engines in the fishing community and were noted for their performance and durability. The engines were built by the Kahlenberg Brothers Company of Two Rivers. Founded in 1895 by William R. and Otto Kahlenberg, the company first designed and built a gasoline marine engine in 1898. In 1914, Kahlenberg introduced the oil engine. Since fuel oil was significantly less expensive than gasoline, the Kahlenberg oil engine soon supplanted the gasoline engine as the most popular choice for fish tugs. Adolph Ruzek sold the *Ranger* to Edward Pupeter of Two Rivers in 1945. Pupeter fished with the boat for three years; after 1948, the *Ranger* fished from Washington Island, Kenosha, and Sturgeon Bay, Wisconsin. (Courtesy of William P. Glandt.)

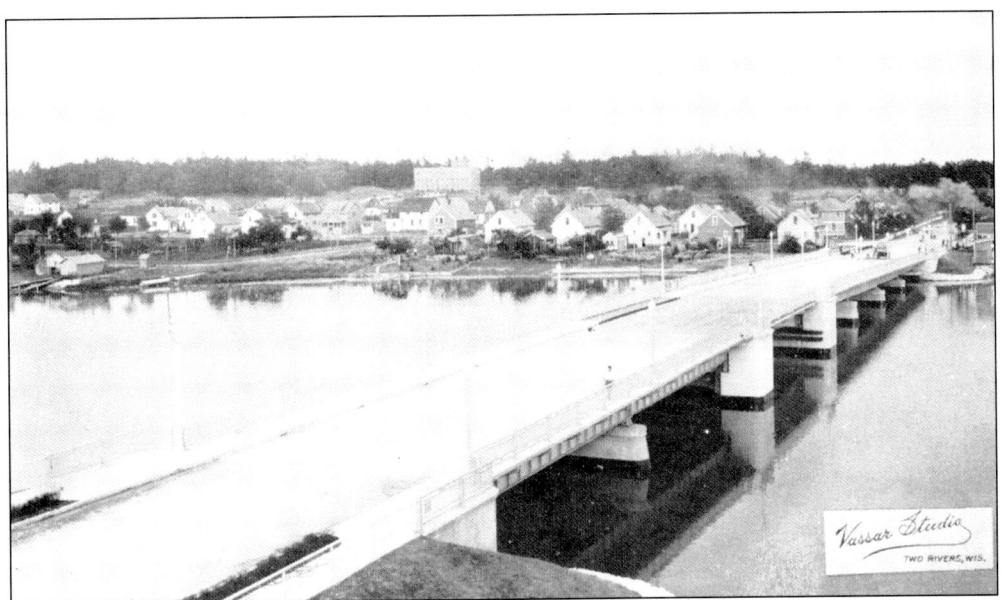

The Twenty-second Street Bridge opened on August 13, 1932. The first bridge at Twenty-second Street, it had been constructed with the assistance of funds from the state of Wisconsin and Manitowoc County and was a modern bascule lift bridge. The cost of the bridge was $200,000. (Courtesy of the City of Two Rivers.)

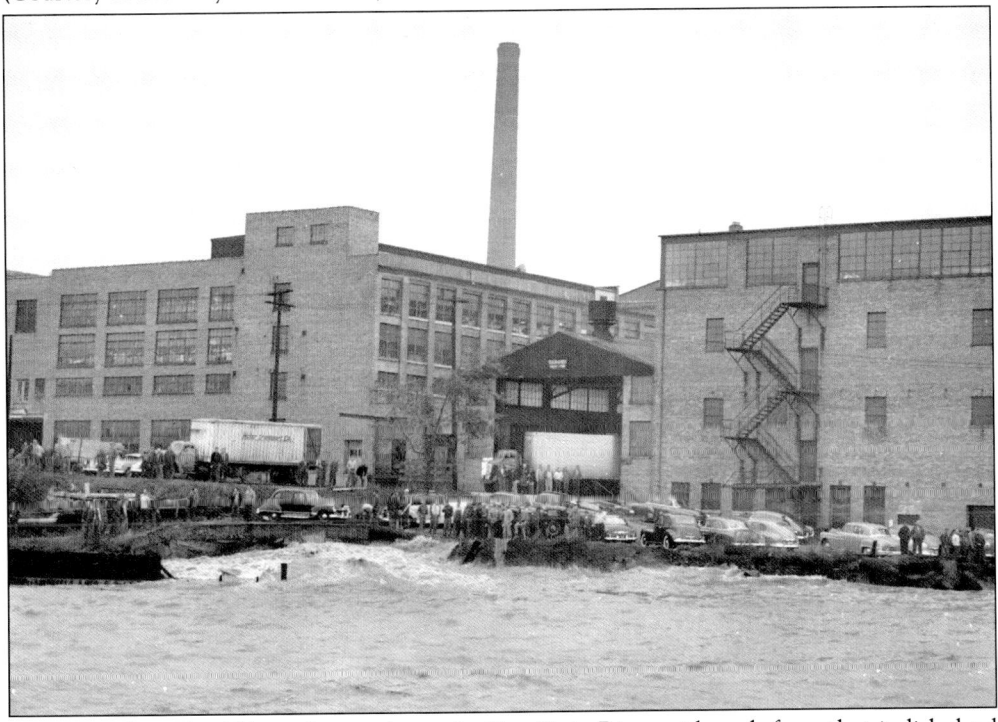

On September 26, 1951, a gale tore down the East Twin River with such force that it dislodged and washed away a 60-foot section of retaining wall at the far southeast corner of the Hamilton Manufacturing Company property. Winds can arise from Lake Michigan with frightening velocity and little warning. (Courtesy of "Life and Industry in Two Rivers: Photos and Catalogs.")

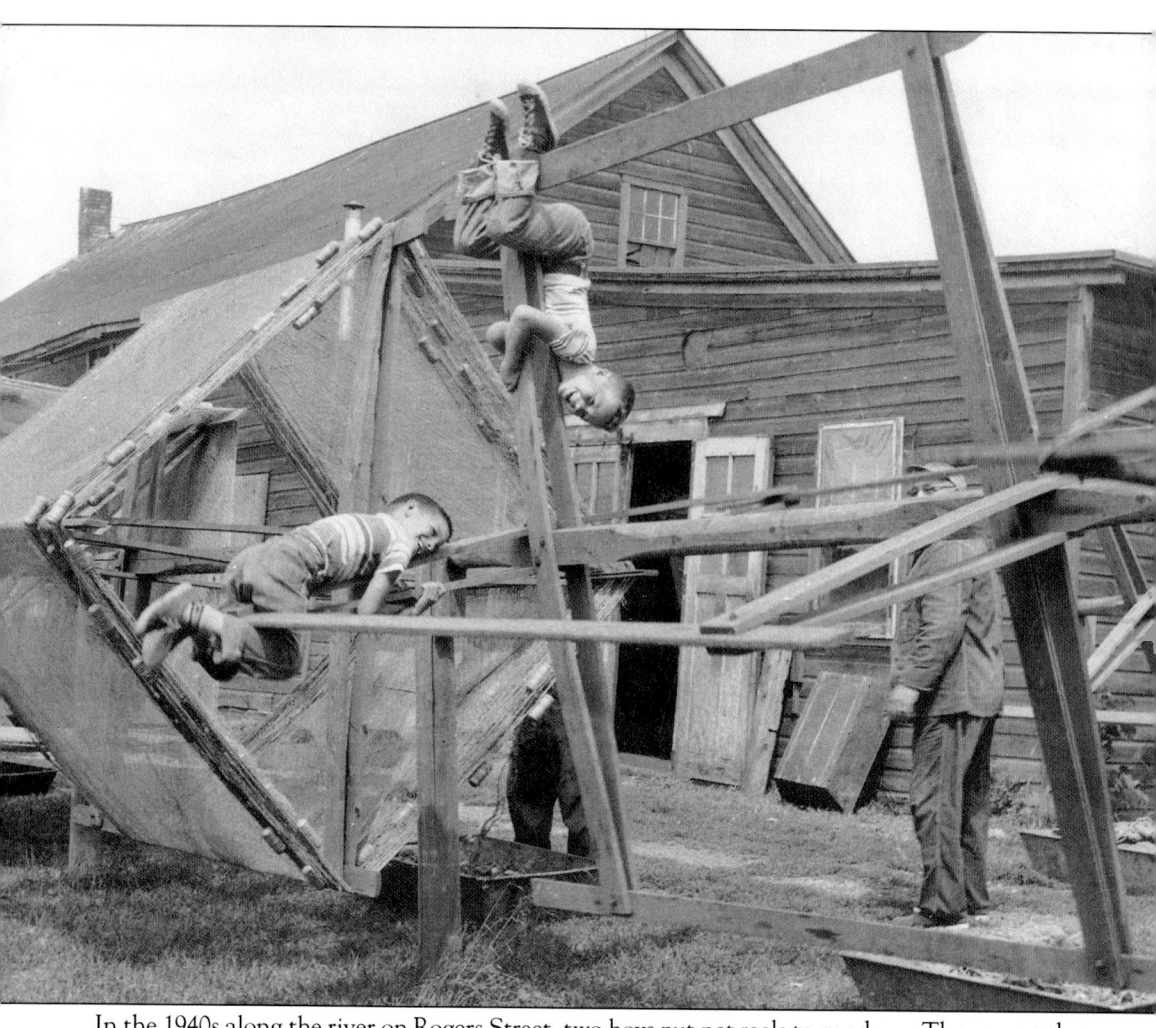

In the 1940s along the river on Rogers Street, two boys put net reels to good use. The man at the right—leading Two Rivers commercial fisherman Everett "Butch" LaFond—seems to be amused. LaFond was a fourth-generation Two Rivers fisher, who had been in the fishing business since 1919. He owned and operated numerous fish tugs during his career. The *Bon Jour*, the *Butch LaFond*, and the *My Sweetheart*, all built by the Burger Boat Company of Manitowoc, were among LaFond's fish tugs. From 1947 to 1955, Butch LaFond, a Republican, represented Wisconsin's First State Senatorial District. LaFond died in 1961 at age 60; he was a member of the Manitowoc County Board until the time of his death. (Courtesy of the Two Rivers Historical Society.)

While the 1950 Seventeenth Street Bridge was built and Seventeenth Street was closed to traffic, a temporary footbridge was installed at Eighteenth Street. In the above photograph, taken on May 3, 1949, a crane from McMullen and Pitz Construction Company of Manitowoc was driving piling upon which the footbridge was to be built. Below, the center span of the 1950 Seventeenth Street Bridge was being set in place. The new bridge used abutments and retaining walls that were from the 1894 bridge. The general contractor for building the bridge was McMullen and Pitz Construction Company. John P. Hoffman was city manager when the bridge was built, and Edward Lahey was city council president. The photograph below was taken from the footbridge constructed at Eighteenth Street. (Both courtesy of "Life and Industry in Two Rivers: Photos and Catalogs.")

Harbor dredging was common during Two Rivers summers for decades. From the 1930s through the 1960s, the US Army Corps of Engineers sent the barge-dipper dredge *Kewaunee* to perform the work. The *Kewaunee*, built in 1913 in Milwaukee, was 109 feet long and had a gross tonnage of 680 tons. The above image shows the *Kewaunee* and barges moored at the C. Reiss coal docks on the West Twin River in 1935. The image below shows the dredge and companion tug, the *Two Rivers,* in action in 1953. Lying idle in Duluth, Minnesota, for years, the *Kewaunee* was dismantled to provide replacement parts for other steam dredges. In 1981, it was stripped of its cabins and sent to Rock Island, Illinois, for refitting as a crane dredge on the Mississippi River. (Both courtesy of the City of Two Rivers.)

An interesting aspect of Two Rivers Harbor dredging in the 1950s and 1960s was that the tug accompanying the dredge was named *Two Rivers*. The trusty tug towed the dredge into and out of the harbor, and towed barge loads of spoils out into the lake where, in those days, they were dumped. The *Two Rivers*, built by the Allen Boat Company of Harvey, Louisiana, for the Army in 1944, was 86 feet long and 23 feet wide. The *Two Rivers* was transferred from the Army Transport Corps to the Army Corps of Engineers, Milwaukee District, in 1947. For over 40 years, it performed towing duties on the Great Lakes for the Army Corps of Engineers. However, dredging technology changed, and harbor dredging was more frequently performed by private contractors. In 1989, the Corps of Engineers sold the *Two Rivers* to Luedtke Engineering Company of Frankfort, Michigan; it was renamed the *Allen K. Luedtke*. Larger ships called infrequently at Two Rivers after 1970, and the city struggled to consistently qualify for harbor dredging funds. (Courtesy of the Two Rivers Historical Society.)

The first Two Rivers *Morning Star* represents an early style of engine-powered fish tug. Built in 1904 by Henry Burger of Manitowoc, its shape resembled that of a mackinaw. It was 40 feet long, eight feet wide, and powered by a 10-horsepower Kahlenberg engine. After 1913, it fished from Michigan and Illinois; there is no record of the tug after 1925. (Courtesy of William P. Glandt.)

When a fishing boat needs to be moved, it cannot always wait until spring! In 1959, the new *Morning Star* carefully made its icy way under the Twenty-second Street Bridge with aid from sled runners. Built by Schwartz Marine for Charles LeClair, it fished from Two Rivers until 1977, when it was sold to William Jensen of Garden, Michigan. (Courtesy of "Life and Industry in Two Rivers: Photos and Catalogs.")

One of the greatest unsolved Two Rivers mysteries is that of the 1958 runaway train. At 3:00 a.m. on Friday, March 7, a Chicago & North Western freight train crashed through track end barriers at the C. Reiss coal yard and into Two Rivers Harbor. The engine and two boxcars entered the water. The train was traveling at almost 50 miles per hour when it entered the harbor. The train had traveled 10 miles from Manitowoc to its resting place in the harbor; no one was in the engine's cab. In these photographs from March 12, 1958, cranes from the McMullen and Pitz Company of Manitowoc lifted the engine and boxcar from the harbor. Traffic control was needed for crowds watching the salvage operation. Despite an FBI investigation, no one was ever apprehended in the incident. (Both, courtesy of the Manitowoc County Historical Society.)

This 1960s photograph shows the Madison Street Bridge in its open position. Two Rivers residents were long accustomed to patient waits as the city's draw bridges opened and closed to admit and say goodbye to sport and commercial fishing vessels from the river harbors. By 2010, the Seventeenth Street Bridge was the only remaining lift bridge in Two Rivers. (Courtesy of "Life and Industry in Two Rivers: Photos and Catalogs.")

When the North Pier Lighthouse was removed from the pier, it was donated to the Two Rivers Historical Society. Here, it was being temporarily placed at the corner of East and Harbor Streets. It was later moved to the Rogers Street Fishing Village and Museum, and there, in 1989, it was once again elevated to its original height. (Courtesy of "Life and Industry in Two Rivers: Photos and Catalogs.")

Three
A Blue-Collar Community

Two Rivers grew to prosperity as a blue-collar manufacturing center. The history of industry in Two Rivers is fundamentally a story of woodenware, aluminum goods, and the Hamilton Manufacturing Company. Together, they defined the city as an industrial center through the mid–20th century. The Mann Brothers sawmill constitutes a valid symbol of industrial Two Rivers. (Courtesy of "Life and Industry in Two Rivers: Photos and Catalogs.")

Two Rivers Manufacturing Company wooden pail and tub factory, owned by the Mann brothers and Hezekiah H. "Deacon" Smith, was located at the end of Seventeenth Street on the east bank of the West Twin River. The view above shows the massive plant from the south, looking across the West Twin River. The view below shows the plant from the northwest with St. John's Lutheran Church visible to the east. The pail factory had its origin in 1857 as H.C. Hamilton & Company. "Deacon" Smith ran that factory. When Joseph Mann arrived in Two Rivers, he bought the pail factory, with Smith continuing as co-owner and manager. See pages 11 and 14 for more information on Smith and Hamilton. (Above, authors' collection; below, courtesy of "Life and Industry in Two Rivers: Photos and Catalogs.")

Joseph, Leopold, and Henry Mann were the kings of Two Rivers industry in the latter half of the 19th century. Their Two Rivers Manufacturing Company built wooden chairs, pails, and tubs and was the world's largest producer of these items. This 1890 photograph shows the chair factory on the south bank of the West Twin River along Monroe Street. (Courtesy of "Life and Industry in Two Rivers: Photos and Catalogs.")

Child labor was accepted and commonplace during the Industrial Revolution. Factory owners and managers often preferred to hire children, since they were considered more manageable, cheaper, and less likely to strike. This practice finally ceased with the passage of the Fair Labor Standards Act in 1938. These children were employees of the Mann Brothers pail factory. (Courtesy of "Life and Industry in Two Rivers: Photos and Catalogs.")

The first labor strike in Two Rivers's history began on August 29, 1895. Workers at the Two Rivers Manufacturing Company pail factory struck. Their demand: payment in cash, not company scrip that had to be spent at the company store. The sign said, "We Want a Cash Payday." After 11 days, the strike was won. William Ahearn was union president. (Courtesy of the Manitowoc County Historical Society.)

On July 12, 1930, the former Mann Brothers sawmill on the West Twin River, then owned and operated by the John Schroeder Lumber Company, was leveled by the most tremendous blaze Two Rivers had ever seen. Two Rivers firefighters had to call in assistance from neighboring Manitowoc, and the two fire departments fought the conflagration for over seven hours. (Courtesy of "Life and Industry in Two Rivers: Photos and Catalogs.")

By 1900, the J.E. Hamilton Holly Wood Type Company became the world's largest producer of movable wooden type. As Hamilton diversified, this building remained the place where type was produced. Hamilton ceased to manufacture the wooden type in 1917 when technology and demand led the company to move in the direction of crafting steel office furniture. (Courtesy of "Life and Industry in Two Rivers: Photos and Catalogs.")

James Edward Hamilton (1852–1940), inventor of wood type, was born in Two Rivers, son of Henry C. Hamilton (see page 14) and Diantha Smith. His initial manufacture of wood printing type in 1880 launched decades of industrial prosperity. Retired after 1920, he became a philanthropist, donating to local churches, contributing Washington High School's pool, and sponsoring the community house named for him. (Courtesy of the Manitowoc County Historical Society.)

By 1926, Hamilton's decision to shift to manufacturing steel office furniture had proven sound, with explosive growth and demand. Additional work space was needed, so this three-story addition was erected at the intersection of Seventeenth and Jefferson Streets by Immel Construction Company. The first floor of the steel plant became the Hamilton Wood Type Museum in 1999. (Courtesy of "Life and Industry in Two Rivers: Photos and Catalogs.")

Before semitrailer trucks ruled the roads and the Interstate Highway System was constructed, the most efficient method of moving massive quantities of goods was steam railways. Here, engine No. 1066 departs Hamilton's East Twin River docking area, heading south, on a cold, snowy, winter day. (Courtesy of "Life and Industry in Two Rivers: Photos and Catalogs.")

In Two Rivers's heyday of prosperity and industrial growth, large manufacturing firms like Hamilton meant much more than jobs to the community. For many workers, their place of employment provided a primary outlet for socialization and camaraderie, as well as a steady wage. This 1923 photograph illustrates the Hamilton Manufacturing Company Band, established in 1920. (Courtesy of "Life and Industry in Two Rivers: Photos and Catalogs.")

After becoming famous for wood type, Hamilton's production diversified into laboratory, medical, and drafting furniture. Then, in 1938, Hamilton began the manufacturing of automatic clothes dryers. After the Jefferson Street plant was expanded to contain at least 40 contiguous buildings, a large facility was built on Columbus Street in 1962. In 1968, Hamilton Manufacturing Company became a division of American Hospital Supply Corporation. (Courtesy of the Manitowoc County Historical Society.)

Joseph Koenig, a German immigrant, was a teacher before he became the first significant American producer of aluminum products in 1895. He established the Aluminum Manufacturing Company and purchased an old factory from J.E. Hamilton for $3,000. Koenig merged his company with two others in 1909 to form what would become the Aluminum Goods Manufacturing Company. Koenig became vice president. (Photograph from Louis Falge, *History of Manitowoc County, Wisconsin*.)

This building, located along Sixteenth Street, was the birthplace of the Standard Aluminum Company in 1911. Standard Aluminum later grew into the Aluminum Goods Manufacturing Company and then the Mirro Aluminum Company. When this photograph was taken around 1912, Standard Aluminum was still young enough that it shared space in this building with two other small manufacturing concerns. (Courtesy of "Life and Industry in Two Rivers: Photos and Catalogs.")

The Aluminum Goods Manufacturing Corporation was a major Two Rivers employer from the early 20th century until the 1980s. This tree-lined view shows what was a central manufacturing district in the city during the 1930s, looking east on Sixteenth Street from Monroe Street. The Aluminum Goods Plant One is on the right; the Two Rivers Beverage Company is on the left. (Courtesy of the Two Rivers Historical Society.)

In the days before everyone had electronic means of communication, a highly effective way to reach large groups of people in smaller cities like Two Rivers was for a company to sponsor a float in a local parade. "Mirro Radio" was Mirro's theme for the year's float, likely in the summer Snow Fest parade. (Courtesy of "Life and Industry in Two Rivers: Photos and Catalogs.")

The F. Eggers Veneer Seating Company was initially established in 1884 by Frederick Eggers as a manufacturer of plywood veneer seating in the order of benches and pews for railroad cars and churches. The structure shown above from about 1890 was the original Eggers Building, located at the intersection of Pine (Nineteenth) and East River Streets. Eggers grew dramatically and had 250 employees in 1912. Frederick Eggers died in 1911 and was succeeded as president by his son Frank. The below image, dating from 1915, was the new Eggers factory, constructed following the rapid growth. While the Depression era was difficult, the company reached new levels of productivity through the leadership of George and James Lester. Eggers Industries remains a prominent 21st-century Two Rivers industry. (Both, courtesy of "Life and Industry in Two Rivers: Photos and Catalogs.")

These workers assembled at the original Metal Ware Corporation site in 1919. The first president was William H. Ellis, son-in-law of Joseph Koenig. The Koenig estate sold the business to a group lead by Elmer Drumm in 1929; the Drumm family has headed the firm ever since. In 1932, the company moved to its current site at 1700 Monroe Street. (Courtesy of the Manitowoc County Historical Society.)

R.G. Suettinger Sheet Metal was a mainstay of Two Rivers's business and industry community. Robert G. Suettinger (1884–1956) operated the tin shop in his father's hardware store. He separated his sheet metal business from the hardware store in 1926 and erected this building in the 1400 block of Sixteenth Street where he and his son conducted the business. (Courtesy of "Life and Industry in Two Rivers: Photos and Catalogs.")

Schwartz Manufacturing Company was founded by Sam Schwartz in 1923. Initially, the company produced fabric buffing wheels, which were purchased by other industries. Filters became the company's primary product in the 1920s. Simon Schwartz (1886–1972) assumed leadership of the company when his father died in 1936. The company's current building at 1000 School Street, with its Art Deco architectural style, was built in 1940. Schwartz Manufacturing nearly doubled its workforce during World War II to produce millions of gun cleaning patches for rifles and machine guns for the US military. Harlan A. Schwartz (1926–2004) became the third of four generations of the same family to own the company. He developed filtering fabrics specifically designed for the filtration of milk. The company has manufactured a wide variety of filter materials for the dairy and food industries since the late 1940s. (Courtesy of the Manitowoc County Historical Society.)

Four

COMMERCE AND PROSPERITY

In Two Rivers, a thriving business sector has always been promoted and considered as a cornerstone of community prosperity. Early industrialists and fishermen sought to diversify into retail enterprises. While Chapter Four covers a wide variety of Two Rivers businesses, it emphasizes business architecture that has attained historic significance. (Photograph by Jeff Dawson.)

John Tadych built the Empire Building in the 1800 block of Washington Street in 1913, a Two Rivers commercial edifice for over 60 years. The businesses located in the Empire Building in the 1960s included Kronzer and Wolf Clothing on Eighteenth Street, and from right to left on Washington Street were Two Rivers Savings Bank, Baetz's, Jaehnig Liquor, the *Two Rivers Reporter*, the Golden Cage tavern, and the Empire Restaurant. (Courtesy of the Two Rivers Historical Society.)

The Lahey & Watson Building was constructed in 1928 at 1806–1810 Washington Street. It accommodated several retail establishments. Lahey & Watson sold electrical appliances and offered plumbing and electrical services. The building is listed in the National Register of Historic Places. This photograph shows the north section of the building. (Courtesy of the Two Rivers Historical Society.)

Beduhn & Goetz sold furniture and also conducted a funeral business. Beduhn & Goetz Funeral Home, at 1504 Eighteenth Street, was constructed in 1925 and is listed in the National Register of Historic Places. The wood frame furniture store was replaced by a brick structure in 1937. The Beduhn Building at 1802–1804 Washington Street is also listed in the National Register of Historic Places. (Courtesy of the Two Rivers Historical Society.)

Schmitt Lumber Company was a supplier of building materials for many years. The company was founded in 1910 by Henry Schmitt. Several of his younger brothers and sons were associated with the business. The company had lumberyards in Manitowoc, Two Rivers, and Algoma, Wisconsin. In this 1920s photograph, the company truck had just completed a Two Rivers delivery. (Authors' collection.)

Joseph Franz Galecki emigrated from Berlin, Germany, in 1898. A tailor by trade, Galecki established a shop on the southeast corner of Walnut (Seventeenth) and Washington Streets. In 1917, he built and proudly posed before this new building at the intersection of Jefferson and Walnut (Seventeenth) Streets. The Galecki Building is listed in the National Register of Historic Places. (Courtesy of "Life and Industry in Two Rivers: Photos and Catalogs.")

In keeping with contemporary norms, Galecki's Clothiers was staffed by family members, close friends, and people who lived nearby. At work in the tailor shop were, from left to right, Emanuel Galecki, Lily Galecki, Bertha Galecki, shop owner Joseph Galecki, Louise Sanville (Glesner), and Emma Gagnon. (Courtesy of "Life and Industry in Two Rivers: Photos and Catalogs.")

Peter Schroeder opened a dry goods business in the Benedict Mayer & Son Building at Washington and Cedar (Eighteenth) Streets in 1891. His brothers Joseph, John, and Frank Schroeder joined the business within five years. Their parents were Prussian immigrants Peter J. Schroeder (1831–1917) and Angeline Rollinger Schroeder (1838–1926). The Schroeder brothers' business thrived and in 1899 property at the southeast corner of Washington and Seventeenth Streets was purchased; a modern, three-story, redbrick building was constructed. The Schroeder Brothers conducted their mercantile business on the first floor, while the upper floors were rented as professional offices and meeting space for fraternal organizations. At the time of this June 9, 1900, photograph—the date of the dedication of the Civil War monument—Schroeder Brothers Company had just moved into its new building. Visible adjacent structures to the south were the Stollberg home, the Stollberg Tavern, and City Bakery. Schroder's is the oldest operating department store in Manitowoc County. (Courtesy of "Life and Industry in Two Rivers: Photos and Catalogs.")

Organized in 1902, the Two Rivers Savings Bank, later known as "the Red Bank," was located inside Schroeder Brothers Company. Bank officers pictured here are, from left to right, vice president Joseph Schroeder, assistant cashier John Schroeder, cashier Frank Schroeder, president Peter Schroeder, and assistant cashier William Priequitz. The Schroeder family was strongly committed to Two Rivers's success. (Courtesy of "Life and Industry in Two Rivers: Photos and Catalogs.")

Schroeder Brothers Company included a grocery store until the 1960s. This early-20th-century photograph shows the interior of the grocery department of the store. Groceries were delivered to customers' homes. The store also sold men's, women's, and children's clothing, shoes, dry goods, crockery, and farm needs. Appliances, drapery, and floor treatments were added in the 1930s. (Courtesy of the Two Rivers Historical Society.)

A comparison of this photograph with the street scene on page 59 demonstrates the changes that occurred on Washington Street over 25 years. The Pillsbury advertisement remained a fixture on the Schroeder Building for many years. Perhaps the most noteworthy aspect of this photograph is the interurban trolley that operated between Manitowoc and Two Rivers for the first quarter of the 20th century. (Authors' collection.)

On a sunny summer day around 1950, Schroeder's Department Store was the center of activity at Seventeenth and Washington Streets. Noteworthy details in the photograph include the mother, child, and baby buggy crossing Seventeenth Street; the stop sign on Seventeenth Street; and the great elm that shades both the street and Central Park. The last Central Park great elm was removed in 2005. (Courtesy of the Two Rivers Historical Society.)

By the late 1960s, Willard Sauve had already prioritized "office supplies" over "toys" in his exterior signage. But for kids growing up in Two Rivers before national chain stores or online shopping, Sauve's was *the* toy store—the place to go to wish and dream. Owned by Tom and Jeanine Henrickson since 1971, the business has evolved into Sauve's Computer and Supply. (Courtesy of the Two Rivers Historical Society.)

Historic buildings abound in this 1918 photograph of the west 1600 block of Washington Street. At left is the Hittner Building. To its right is the Stephany Building (1618 Washington Street), built in 1917 and listed in the National Register of Historic Places. To its right are the businesses of John Braun, pioneer jeweler, and his son Paul, photographer. (Courtesy of the Manitowoc County Historical Society.)

The Hittner Building (1616 Washington Street) was constructed as a two-story structure by Dr. Henry Hittner, an early physician, to be used for his office. A third floor was added, giving the building its distinctive appearance. Hittner died in 1892. Listed in the National Register of Historic Places, it has been home to many businesses, including a funeral home, a styling salon, restaurants, and taverns. (Authors' collection.)

The Richter Building (1600 Washington Street) built in 1880, is listed in the National Register of Historic Places. It is one of the oldest structures in Two Rivers. B.F. Richter, who constructed the building, was a Civil War veteran who was an accountant for the Two Rivers Manufacturing Company and a notary public. He served two years (1872 and 1877) as Two Rivers village president. (Authors' collection.)

Around 1940, the main floor of the Richter Building was occupied by Schneider, Inc., a clothing store operated by Raymond Schneider. Schneider also sold furniture. The Soit Tailor Shop occupied the lower basement level of the building. A.J. Rehrauer Paints was located next door. In the 1960s, the Richter Building was home to Scheurell's Clothing, before becoming the Copper Kettle Restaurant. (Courtesy of the Two Rivers Historical Society.)

Robert Carl Suettinger emigrated from Germany in 1847 and established Two Rivers's first hardware store at Smith Avenue (Fifteenth Street) and Washington Streets. In 1862, he constructed this building on the northeast corner of Main (Sixteenth) and Washington Streets, and in 1937, the building burned. Suettinger's Hardware, Two Rivers's oldest retail firm, relocated to 1407 Sixteenth Street in 1958. (Courtesy of "Life and Industry in Two Rivers: Photos and Catalogs.")

Every downtown needs a drugstore, and for many years in Two Rivers, one could be found at 1523 Washington Street. A frame structure was built there by Charles F. Kirst, who practiced as a druggist for almost 60 years. Kirst was succeeded by Plantico Drugstore and by Wolfe Snyder Drugstore in a new building shared with Dalebroux Jewelry. (Courtesy of "Life and Industry in Two Rivers: Photos and Catalogs.")

Opportunities for women in the workforce were severely limited in the late 19th and early 20th centuries. One occupation open to them was telephone operator. Two Rivers telephone service began in the late 19th century with J.E. Hamilton, Gustav Kirst, and Charles Kirst as initial investors. The local telephone service was purchased by the State Telephone Company in 1927. (Courtesy of "Life and Industry in Two Rivers: Photos and Catalogs.")

Two Rivers's own brewery began in 1848 as the Edward Mueller City Brewery at 1608 Adams Street. The Muellers drilled a well 860 feet deep to obtain the water necessary for brewing. Their beer was renowned for remarkably crisp flavor, lent to it by the water. The brand name of the beer was Golden Drops, first bottled in 1902. (Courtesy of "Life and Industry in Two Rivers: Photos and Catalogs.")

Frank Liebech, George Eisenbeis, and Andrew Eisenbeis bought Mueller Brothers Brewing in 1915. Their Two Rivers Beverage Company brewery continued brewing Golden Drops Beer. During Prohibition, the company produced near beer, soda, and ice cream. White Cap Beer was introduced in 1939. Bobbie Ale was the most popular of several specialty brews. This photograph shows the brew house and the bottling plant. (Courtesy of the Manitowoc County Historical Society.)

The Two Rivers Beverage Company remained at 1608 Adams Street; the property contained a brewery and associated facilities. White Cap Beer emerged as the company's best-selling product and became known as "the Two Rivers Beer" during the 1940s and 1950s. Two Rivers Beverage Company was a union brewery. In this image from the mid-1950s, new tanks were being installed. (Courtesy of the Manitowoc County Historical Society.)

In 1963, Pres. Harold Liebech (left) and brewmaster George Liebech introduced Liebrau Beer to replace White Cap Beer as their brewery's primary product. However, brewery sales continued to decline under pressure from national breweries. The Liebech family had owned the brewery since 1915 but was forced to close in 1966, heralding the end of the era of small, independent Wisconsin breweries. (Courtesy of the Manitowoc County Historical Society.)

The Bank of Two Rivers was incorporated in 1895; original stockholders were bank founder David Decker, Edward Decker, J.E. Hamilton, Charles E. Mueller, Leopold Mann, Peter Gagnon, and Walter Mann. First housed in a frame building and then in a brick building, the bank was always located at 1516 Washington Street. (Courtesy of "Life and Industry in Two Rivers: Photos and Catalogs.")

Two Rivers was growing rapidly, and there was a demand for accommodations that exceeded the standards and comforts afforded by rooming houses and transient hotels. Becoming the first lodging of its kind in the city, the grand Hotel Hamilton opened for business on July 6, 1905. It was located at 1500 Washington Street. (Courtesy of "Life and Industry in Two Rivers: Photos and Catalogs.")

It had hosted wedding receptions, society events, and thousands of visitors for many years, but by the 1950s, the heyday of the Hotel Hamilton had come and gone, and the building was looking decidedly worse for wear. After standing vacant for years, the once swanky structure hosted its final guest in 1960 in the form of a wrecking ball. (Courtesy of "Life and Industry in Two Rivers: Photos and Catalogs.")

C. Reiss, a Sheboygan coal company established in 1880, acquired the Two Rivers coal docks at the West Twin River and the harbor. These docks had been established by the Two Rivers Coal Company, an entity formed by local industrial firms. In 1944, when this photograph was taken, C. Reiss coal boats were the largest vessels to regularly visit Two Rivers. (Courtesy of the Two Rivers Historical Society.)

Establishing and maintaining a successful hotel was a challenge in Two Rivers until the advent of the Lighthouse Inn. In 1965, construction of Two Rivers Lodge began on lakefront property across Memorial Drive from Lakeshore Park. Construction ceased after eight months when the building was only partially finished. After one restart, the development was abandoned and stood for years in progressively deteriorating condition. James VanLanen Sr. built a hotel/restaurant, initially called the Carlton Inn, on the site in early 1973. When it opened, the new facility was "Among Wisconsin's Finest," offering "restful dining in a nautical atmosphere overlooking beautiful Lake Michigan." Ever since, the Lighthouse Inn has given Two Rivers a top-quality hotel and restaurant to greet visitors as they enter the city. (Above, authors' collection; below, courtesy of the Two Rivers Historical Society.)

A trolley service operated between Manitowoc and Two Rivers from 1902 until 1927. The system was built in 1901 by Thomas Higgins and was known as the Manitowoc and Northwestern Traction Company. The original caption on this photograph reads, "Around the curve," as the trolley makes the turn from along the lake onto Washington Street. (Courtesy of the Two Rivers Historical Society.)

For decades, rail service was essential to any American city. Passenger service was important, but for a manufacturing center like Two Rivers, freight service was also critical. So this event was a calamity in that freight commerce was impaired for days. This major wreck occurred on February 29, 1927, on the main track between Manitowoc and Two Rivers. (Courtesy of "Life and Industry in Two Rivers: Photos and Catalogs.")

FORMAL OPENING SALE
GAGNON'S KEENWAY STORE

2314 Washington St. Phone 7632

3 MONEY SAVING DAYS

THURSDAY, FRIDAY, SATURDAY **OCTOBER 2-3-4**

OPEN SUNDAYS FROM 9 A. M.-12 NOON, 4-6 P. M.
FRESH BREAD AT 4:00 P. M. ON SUNDAYS

FREE DELIVERY EVERY MORNING AT 10:00 A. M.

BIG VALUES FOR FINE GROCERIES

- IVORY SOAP . . . Lge. Bar **15¢**
- Kerr Quarts, Complete With Covers
 FRUIT JARS Doz. **73¢**
- The Quality Coffee in the Glass Jar
 KEENWAY COFFEE Lb. Jar **48¢**
- Your Choice of Popular Bars
 CANDY BARS . . . 3 for **14¢**
- NOVEL WASH BLEACH Gal. **38¢**

VEGETABLES

- California 252 Size Valencia
 ORANGES 2 Doz. **49¢**
- Illinois Jonathan
 APPLES 3 Lbs. **32¢**
- New Crop Louisiana
 YAMS . . 2 Lbs. **19¢**
- Italian ½ bu. box $2.69
 PRUNES . 2 Lbs. **23¢**

FELS NAPTHA SOAP 3 bars 27¢

| Keenway Fine Quality **SALAD DRESSING** Pt. **29¢** | Welch's Pure **GRAPE JAM** Lb. Jar **25¢** | **CARNATION MILK** 3 Tall Cans **37¢** | Toilet Soap **SWEETHEART** 3 Bars **28¢** Special Offer—Mail in the wrappers from 3 bars and you will receive 3 dimes in return. Your chance to buy and try Sweetheart Soap at no cost. |

Plain or Iodized **KEENWAY SALT** 2 Lb. Box **6¢** All Purpose Cleaner Package **SPIC AND SPAN** Pkg. **20¢**

Before the days of supermarkets, small grocery stores were found in every neighborhood. Some Two Rivers neighborhoods were served by several grocery stores. In 1948, there was new ownership for the store serving the near north side. Joseph P. and Rose Gagnon advertised the opening of their store at 2314 Washington Street. In the post–World War II era, small stores sought to attract business by combining bargains with a personal touch. The 1948 prices are interesting, but also note that the store provided free delivery each day and offered fresh bread on Sunday afternoons. The Gagnons were not long-term proprietors. They sold the business to Frank and Caroline Kochorosky only a year after this advertisement. The Kochoroskys operated the store for several years, and when they closed it in the mid-1950s, no one took their place. Neighborhood grocery stores in Two Rivers started to disappear one at a time, with the noteworthy exception of Rollie's South Side Food Market. (Authors' collection.)

It was the Fourth of July at the A.J. Maack and Messman store on the east side in this photograph from about 1910. Flags and fireworks were prominently advertised. From the 1930s until 1960, the building was a neighborhood grocery store, operated by John A. "Jack" Gates. Located at 1718 East Street, the building's original design remains virtually intact. (Courtesy of the Two Rivers Historical Society.)

Dr. John Randolph Currens was regarded as one of Two Rivers's greatest citizens, resulting from his sustained medical career and the pride he took in the city's civic life. Dr. Currens practiced medicine in Two Rivers for 50 years and was the mayor from 1905 to 1909 and 1915 to 1921. (Courtesy of "Life and Industry in Two Rivers: Photos and Catalogs.")

It was winter in Two Rivers. Fresh snow had recently fallen. It was a good day to stay at home close to a nice warm fire. But, there were hospital patients who needed their doctor. Perhaps, it was time for the morning rounds, or perhaps, there was an emergency. Regardless of the reason, Dr. Richard E. Martin was making his way up the hospital steps in this classic image of a physician's dedication. The photograph was taken from inside the main entrance of the original Two Rivers Hospital on Garfield Street. Dr. Martin was born in 1905 and spent his professional career practicing in Two Rivers and Manitowoc. His office was located in the second-floor office complex of the Lahey & Watson Building at 1806 Washington Street. Many Two Rivers babies born between 1940 and the early 1970s were delivered by Dr. Martin. After a number of years in retirement, he died in 1992. (Courtesy of "Life and Industry in Two Rivers: Photos and Catalogs.")

Five
PROGRESSIVE CITIZENSHIP

Two Rivers has a long tradition of progressive citizenship and government. From early Populist and socialist political influence to the advent of municipal utility ownership, to the adoption of the city manager form of government, Two Rivers's citizens have consistently sought ways to make government effective and responsive. In 1858, the village of Two Rivers was created, and in 1878, Two Rivers became a city. Pictured is the Flag and Guard in front of the J.E. Hamilton Community House during EthnicFest in 2010. (Photograph by Jeff Dawson.)

Built in 1874 at a cost of $5,000, Two Rivers's original municipal building was located on the northwest corner of Washington and Walnut (Seventeenth) Streets. It housed city hall, the fire station, and the police department. It was demolished in 1938, and bricks from the old city hall were used to construct the ticket office at the new Walsh Field. The current city hall, located at 1717 East Park Street, was originally constructed in 1903 as the H.P. Hamilton School and was the city high school until Washington High School was built in 1922. The completely remodeled city hall was rededicated on July 22, 1993, and is listed in the National Register of Historic Places. (Above, courtesy of "Life and Industry in Two Rivers: Photos and Catalogs;" below, authors' collection.)

A visiting carnival erected a celebratory archway at Eighteenth Street in 1904. Attractions were set up on both sides of Washington Street between Eighteenth and Twentieth Streets. In 1904, streetcar tracks ended at Sixteenth Street. They were eventually extended to Twenty-second Street. The Civil War monument at center was later moved out of the roadway into Central Park. (Courtesy of "Life and Industry in Two Rivers: Photos and Catalogs.")

A unique event in Two Rivers's city history occurred when a hot-air balloon landed on October 18, 1910—and not too softly! The balloon, *Condor,* was a French entry in a race for the Bennett Cup. The pilot was Jacque Faure. Departing from St. Louis the previous day, *Condor* landed after traveling 413 miles, good for ninth place in the 10-balloon race. (Courtesy of the Manitowoc County Historical Society.)

The Wisconsin Socialist movement reached its northern lakeshore terminus at Two Rivers. Milwaukee and Manitowoc elected Socialist mayors for extended periods. Two Rivers Socialists, frequently meeting at Kapplemann's Hall, consistently elected local and state candidates from 1903 through 1918. The *Two Rivers Reporter* was founded by Fred Althen as a weekly Socialist newspaper in 1905. Poet Carl Sandburg was the lakeshore organizer for the Socialist Party of America. The zenith of Two Rivers's connection to the national Socialist movement occurred in February 1901; Eugene V. Debs, left, a five-time candidate for president, spoke to a standing-room-only crowd in Two Rivers. Debs received 18 percent of the presidential vote in Two Rivers in 1912. (Above, courtesy of "Life and Industry in Two Rivers: Photos and Catalogs"; left, authors' collection.)

It was a significant public event when Two Rivers sent its sons off to the Great War. On September 22, 1917, soldiers left Two Rivers from the railroad station along Twelfth Street, heading for duty and uncertainty in World War I. Two Rivers lost 11 men in the war, including American Legion Post No. 165 namesake Robert E. Burns. (Courtesy of "Life and Industry in Two Rivers: Photos and Catalogs.")

Thomas J. Walsh (1859–1933), US senator from Montana, is Two Rivers's most famous son. He moved to Montana in 1890 and was elected to the Senate in 1912. Walsh was a progressive Democrat, supporting women's suffrage and workers' rights. The dedication at Walsh Field reads, "We salute you, Thomas J. Walsh, Lamplighter, baseball player, teacher, principal, lawyer, and Senator." (Courtesy of the Two Rivers Historical Society.)

A group of prominent Two Rivers movers and shakers gathered for this photograph. Fifty years earlier, they were the "boys" of the 1870s, members of the Centennials, Two Rivers's first baseball team. (See page 17.) From left to right, they were William Ahearn, Fred Schnorr, Fred Beth, J.E. Hamilton, Maurice Fishbein, and Thomas J. Walsh. By the 1920s, they had all made significant achievements. Ahearn, a pail turner by trade, was a union leader at Two Rivers Manufacturing Company and a leader of the local turnverein. In 1914, Schnorr, a lather who was born in England, built the Schnorr Building, 1610 Washington Street. It is listed in the National Register of Historic Places. J.E. Hamilton, of course, was the founder of Hamilton's Manufacturing Company. Thomas J. Walsh was most famous. Son of early Irish settler, Felix Walsh, Thomas was a Montana senator and was nationally recognized as the leading force in exposing the Teapot Dome Scandal during Pres. Warren Harding's administration. When Schnorr died in 1947, the entire "team" was gone. (Courtesy of "Life and Industry in Two Rivers: Photos and Catalogs.)

On May 1, 1925, Two Rivers voted to adopt the city manager/council form of government, replacing the mayor/aldermanic system that had been in place since the city's incorporation in 1878. The concept of city manager government originated as a Progressive-era (1900–1920) reform for local government. Under the city manager governmental form, city council members are elected at large, representing the entire city rather than single aldermanic districts. The city council then hires a city manager with professional expertise to administer city services. In 1925, the Two Rivers City Council employed Richard Biehl as the first city manager at a salary of $5,000. Biehl had previous experience as city manager of Westerville, Ohio. The first city council under the city manager form of government included, seated from left to right, Henry E. Zuehl, Peter J. Schroeder, Thomas Gagnon, Dr. Albert M. Farrell, City Manager Biehl, Harry C. Gowran (the last Two Rivers mayor), Arnold W. Zander, William R. Kahlenberg, Nic Taddy, and Kurt H. Wilke. Standing, from left to right, are city attorney F.W. Dicke, city clerk John G. Weilep, and city engineer Charles J. Popelka. (Courtesy of the Two Rivers Historical Society.)

On October 5, 1926, Two Rivers police officer Leo Rocque was shot and killed in an ambush attack. The 48-year-old, five-year police force veteran was on night duty in the combined police and fire station at Seventeenth and Washington Streets. Rocque was called to the back door; a shot rang out. Officer Rocque was shot through the door with a single rifle round. Struck in the throat, Rocque died in minutes but not until he raised a racket with his police club, awakening firefighters sleeping in the building. Evidence was collected by city manager Richard Biehl, but when Biehl left Two Rivers, the evidence left with him. Contemporary theories connected Rocque's murder to Prohibition-era bootlegging activity. The killer was presumed to be an outside professional. The murder remains one of Two Rivers's unsolved mysteries. The Two Rivers Law Enforcement Memorial Bridge (Twenty-second Street Bridge) is dedicated in honor of Rocque and Thomas Dodge, the only other Two Rivers police officer to die in the line of duty. Dodge died in 1975. (Courtesy of the City of Two Rivers.)

In 1935, the Works Progress Administration (WPA) was established by Franklin Roosevelt and funded by Congress to employ the chronically unemployed in working on public works projects. Two Rivers eagerly participated, as shown in this 1936 school painting project. In 1936, approximately 175 Two Rivers residents were paid $130,000 in WPA wages; all were qualified for direct welfare before being employed. (Courtesy of the City of Two Rivers.)

In 1901, Two Rivers voters approved the establishment of a municipally owned water and electrical utility and authorized a $65,000 bond for that purpose. J.E. Hamilton was the first water and light commission president. In 1924, after years of debate, the source of city water was changed from shallow wells to Lake Michigan. This new water filtration plant was opened in 1935. (Courtesy of the City of Two Rivers.)

The first road between Two Rivers and Manitowoc was a privately owned plank road that charged a toll until 1876. A concrete road was built around 1915. When Wisconsin's trunk highway system was laid out in 1918, the road was designated State Highway 17. It became a segment of State Highway 42 in 1930. This view looks north toward Two Rivers. (Courtesy of William P. Glandt.)

In 1952–1953, Washington Street was widened to four lanes, electric lines were placed underground, and vapor luminary lamps were installed. The new lights were dramatically evident in this period photograph of the 1500 block of Washington Street. Montgomery Ward, Two Rivers's largest chain store, is in the foreground. To the north (left) were Harlow's Grocery, J.C. Penney, Two Rivers Hardware, and Plantico's Rexall Drugstore. (Courtesy of the City of Two Rivers.)

It was a banner day in 1871 when Two Rivers obtained its first steam-driven fire engine! When photographed about 1925, it was still in use. Edward Lahey, the city's first paid fire chief, stands at left, near the horses. The other firefighters shown are, from left to right, Harley Lawler, Charles Waskow, Ervin Monk, Arthur Rahn, and Alex LaFleur. (Courtesy of "Life and Industry in Two Rivers: Photos and Catalogs.")

Two Rivers's 1940s fire department proudly poses with the fire engines of the day in front of the new fire station, built in 1933 at 2120 Monroe Street. Chief William England is at far left. Beginning in 1919, Two Rivers had a paid fire department; before then, all firefighters had been volunteers. (Courtesy of "Life and Industry in Two Rivers: Photos and Catalogs.")

Imagine day-to-day life without the convenience of package delivery by mail. As shown in this photograph of Two Rivers's very first day of parcel post service, it was a new phenomenon in the 1920s. Parcel post deliveryman Louis Schultz strove to sort out the chaos of jumbled packages and deliver them safely. (Courtesy of "Life and Industry in Two Rivers: Photos and Catalogs.")

Constructed in 1932, the Two Rivers Post Office Building at 1516 Eighteenth Street has proven to be a functional workhorse and remained the city post office into the 21st century. The lobby areas display the charm and attention to detail devoted to official buildings in its era of construction. It is listed in the National Register of Historic Places. (Courtesy of "Life and Industry in Two Rivers: Photos and Catalogs.")

By 1928, Two Rivers's size and population had created a significant demand and need for a medical treatment center, and the Two Rivers Municipal Hospital opened for business. Pictured here are, from left to right, original hospital employees Carl Bloomquist, May McCullough, Verneal Rohrer, Myrtle Burgener, and Dr. Albert Farrell. This hospital became a nursing home in 1963. (Courtesy of "Life and Industry in Two Rivers: Photos and Catalogs.")

The new Two Rivers Municipal Hospital was located on the west side of Picnic Hill, just north of the 1928 hospital. It was dedicated on December 15, 1963. At that time, the hospital was owned by the city and directed by a public hospital board. The cost of the new hospital was $1.75 million. On dedication day, 2,000 people toured the facility. (Courtesy of the City of Two Rivers.)

On December 17, 1891, the Joseph Mann Library opened its doors. Located on Sixteenth Street in the 1500 block, it was named for Joseph Mann, one of the Mann brothers, whose wife was the library's initial benefactor. The cost of the library including building, heating, furniture, and initial book collection was a mere $3,363.73. Lizzie Yahnke was the original librarian. (Courtesy of "Life and Industry in Two Rivers: Photos and Catalogs.")

During the bleak year of 1933 in the depths of the Great Depression, 656 children registered to use the library between June and December, including these eager patrons. A Carnegie library building erected in 1914, the Joseph Mann Library was located on the north side of Sixteenth Street between Washington and Adams Streets until the Lester Public Library was dedicated in 1997. (Courtesy of the City of Two Rivers.)

February 22, 1922, was the date of a sleet storm described as "the worst in history." The storm swept from LaCrosse through Manitowoc, producing a layer of heavy ice. Storm damage in Two Rivers was evident in the 1700 block of Washington Street. Statewide there were 10 train wrecks, 15,000 utility poles destroyed, and 1,000 miles of downed wires. (Courtesy of "Life and Industry in Two Rivers: Photos and Catalogs.")

This photograph dates from the 1950s, yet the scene could be from last winter. The windrowing of snow was underway at the intersection of Sixteenth and Washington Streets. Identifiable businesses include Staidl Jewelry, Plantico Rexall Drug, the S.S. Kresge Company, and Schroeder's Department Store on the right side of the street and the Bank of Two Rivers on the left side. (Courtesy of the Two Rivers Historical Society.)

When old-timers talked about severe Two Rivers winters, 1936 was usually mentioned first. This February 1936 photograph of the road between Manitowoc and Two Rivers gives a good perspective on snow volume. Note the comparison between the snow banks and telephone wires; the snow banks were 10 feet high. By early January 1936, people began to worry that the winter would be one of history's worst. A mid-January nor'easter brought waves of drifting snow, closing all roads except Memorial Drive between Manitowoc and Two Rivers. Temperatures dropped to 20 degrees below zero for five days in late January, and there were 20 days of below zero temperatures in January and February. There was no January thaw in 1936. More snow followed with another blizzard in early February, and all attempts to keep roads open were abandoned. Car ferry service was suspended. Schools were closed for several days, and no mail was received on the lakeshore for three days during the first week of February because train tracks south of Manitowoc were impassable. (Courtesy of the Two Rivers Historical Society.)

Six

LEARNING ON THE LAKESHORE

Two Rivers's first school was started through the efforts of Hezekiah H. "Deacon" Smith in 1849. The first high school was established in 1877. Only 63 Two Rivers students had completed high school by 1893. After 1910, attendance laws were enacted, and high school enrollment increased significantly. This chapter provides a brief perspective on the evolution of both public and private education in Two Rivers. (Photograph by Jeff Dawson.)

This two-story white frame building was the first centralized school, built on property bounded by East Park, Eighteenth, and Jefferson Streets. The land was purchased from Hezekiah H. Smith and Joseph Mann in May 1866. Additional buildings were constructed on this site in 1877 and 1897. These schools had a wood-burning stove in each classroom but lacked indoor plumbing. (Courtesy of "Life and Industry in Two Rivers: Photos and Catalogs.")

This photograph from 1889 occasioned a winter assembly on the eastern Jefferson Street side of the school complex. The original 1866 school building and the 1877 building on the right are visible. Several students took advantage of the leafless trees to improve their position in the picture. Note the large woodpile maintained for heating the schools. (Courtesy of the Two Rivers Historical Society.)

Roosevelt School, at School Street and Roosevelt Avenue, was the first public school on the south side of Two Rivers. It was named for Pres. Theodore Roosevelt, probably when the north wing was added in 1909. The south wing was built in 1892. When Koenig School was opened in 1931, Roosevelt School was closed and, in 1941, sold to Crescent Woolen Mills. (Courtesy of the Two Rivers Historical Society.)

By 1905, Two Rivers had outgrown its first centralized school building and pressed forward with construction of a far more sizable edifice: this new, redbrick structure, the H.P. Hamilton School. After use as a high school, elementary school, and vocational school, the building became Two Rivers City Hall. See page 76 for a front view of this building. (Courtesy of "Life and Industry in Two Rivers: Photos and Catalogs.")

ENROLLMENT CHART
FOR PUBLIC & PAROCHIAL GRADE SCHOOLS & HIGH SCHOOL FOR THE YEARS 1929 to 1936

	1929	1930	1931	1932	1933	1934	1935	1936
PAROCHIAL SCHOOLS	1292	1257	1212	1211	1261	1264	1272	1267
GRADE SCHOOLS (1st to 8th Grades)	762	833	878	909	894	879	823	823
HIGH SCHOOL (9th to 12th Grades)	382	445	493	562	615	626	629	667

The *Two Rivers 11th Annual Report* from 1936 included this chart. It provides interesting perspectives on education in the city during the Depression years. There were four parochial schools in the city at the time, St. John's Lutheran School and St. Luke, St. Mark, and Sacred Heart Catholic Schools. Parochial schools, offering a first-through-eighth-grade elementary education, enrolled approximately 50-percent more students than the public elementary schools during this period. Both parochial and public elementary schools experienced fluctuations in enrollment during these years. High school enrollment increased dramatically during the years analyzed by the chart. Initially, high school students came primarily from wealthier families or were students determined to pursue professional careers. Most students completed elementary school and then withdrew from school to earn a living or to add to their family's income. High school enrollment had grown steadily through the early 20th century. But, the lack of available employment during the Depression years motivated students, who would have previously dropped out, to remain enrolled throughout high school. (Courtesy of the City of Two Rivers.)

On September 6, 1922, the *Chronicle* proclaimed, "New High School Building—One of the Finest in the State." This image shows the brand new Washington High School, featuring flower beds and automobiles in a rather idyllic setting. The new school was built at the northern terminus of Washington Street on property bounded by Adams Street, Twenty-seventh Street, and the East Twin River. Built by Hansen Construction Company of Green Bay, the school building cost $540,000. J.F. Magee was president of the board of education, and Fred G. Bishop was superintendent of schools in 1922. Children in grades kindergarten through high school originally attended the school. Space for a pool was incorporated into the new school, but limitations in construction funds prevented actually building it. J.E. Hamilton personally donated funds to allow construction of the pool. The new school's spacious gymnasium stimulated heightened levels of interest in high school athletics, especially basketball. When Two Rivers High School was built in 2002, Washington High School was demolished and replaced by a housing development. (Courtesy of the Manitowoc County Historical Society.)

Washington High School, seen here from the north, had three stories, two athletic fields, a swimming pool, gymnasium, and industrial arts facilities. The modern new high school boasted enviable facilities and afforded plenty of space for further expansion. During its life span, there were several additions to Washington High School. (Courtesy of "Life and Industry in Two Rivers: Photos and Catalogs.")

The George M. O'Brien Physical Education Unit was the final addition to Washington High School. Opened in 1966, it was constructed on the northeast corner of Twenty-seventh and Adams Streets. The building contained a large gymnasium and a pool. The building was named for O'Brien, superintendent of schools at the time. This view shows the Adams Street entrance to the addition. (Courtesy of the Two Rivers Public School District.)

In 1941, for the only time in history, the Washington High School Purple Raiders won the state basketball tournament. The team was undefeated, posting a 21-0 record; its Northeastern Wisconsin Conference record was 10-0. On March 15, 1941, the team won the state championship by a score of 35-28 over Shawano in a game played at the University of Wisconsin Field House in Madison. The starting five on the 1941 team included, from left to right, Lawrence "Cat" Antonie, Leroy Shimulunas, Vic Gauthier, Ken Wondrash, and Reuben LeClair. The team was coached by mathematics instructor Ed Hall. Wondrash led the team in scoring with 207 points; Antonie was second with 167 and LeClair third, tallying 149. Leroy Shimulunas enlisted in the Army 10 days after graduating from Washington High School in June 1941. A glider pilot, Shimulunas died at the age of 23 during World War II in Burma. Shimulunas was declared missing in action in March 1944; his death was not verified until February 1946. (Courtesy of the Two Rivers Public School District.)

Given the number of German immigrants residing in Two Rivers, a Lutheran church was established in 1863, early in the city's history. A school was greatly desired by the congregation and was founded in 1866 with Pastor Carl Braun as teacher. St. John's Lutheran School, shown here, was built in 1905 and served the congregation until 2000. (Courtesy of "Life and Industry in Two Rivers: Photos and Catalogs.")

St. Luke Catholic School 1907 graduates posed with the parish priests. From left to right are Bess Blaha, Elizabeth Schroeder (Scheuer), Raymond Schneider, Rose Geimer (Sister Imelda, CSA), Rev. Claude Hugo, Rev. Joseph Geissler, Charles Allie, Julia Hammel, Dorothy Bartelme (Weix), Agnes Kotchi (Scheuer), and Raymond Ahearn. The school building at Eighteenth and Jefferson Streets is in the National Register of Historic Places. (Courtesy of St. Peter the Fisherman Catholic Parish.)

Seven
Places of Worship, Communities of Faith

Christian faith and worship were important aspects of life in Two Rivers from the earliest days of Euro-American settlement. Congregationalist, Lutheran, and Catholic communities all trace their birth to missionary visits in the early 1850s. This chapter provides an eclectic overview of the church buildings that gave architectural character to the cityscape. This image is of the Calvary Evangelical Lutheran Church bell tower. (Photograph by Cassandra Gagnon Kronforst.)

Grace Congregational Church traces it origins to an 1849 visit by Rev. William Herritt from the Congregational Church Home Mission Board. By 1851, a local Congregational community came together. A church was built in the 1500 block of Washington Street in 1857. Hezekiah H. "Deacon" Smith was one of the original deacons in the church and a strong supporter of the construction of the first church. The first Congregational church acquired property at Twenty-fifth and Washington Streets in 1906, and by 1908, this new church had been constructed. The original cost of the church was $14,000, half of which was donated by J.E. Hamilton. When the church was dedicated on March 7, 1909, it was named in memory of Hamilton's daughter Grace who had died in 1905 at only 24 years of age. By 1911, a bell and a pipe organ were added. The church celebrated its centennial in 1950–1951. Grace Congregational Church (United Church of Christ) moved to its current church building at 2801 Garfield Street in 2004. (Courtesy of the Two Rivers Historical Society.)

St. John's Evangelical Lutheran Church was built during the winter of 1888, and when warmer weather rolled around in 1889, the spire was added. St. John's was founded in 1863 and sanctioned by the Wisconsin Lutheran Synod. Initially, services were held at "Smith's meetinghouse" in the 1500 block of Washington Street where the Congregationalists met. When St. Paul's Episcopal Church, built in 1856, fell idle during the Civil War, the Lutheran congregation purchased it. Located at Walnut (Seventeenth) and East Park Streets, it was the older, much smaller church seen here on the left. German immigration swelled church membership in the 1880s, and facilities became inadequate. The decision was made to construct a new church. Note the elaborate and rather rickety scaffolding. Working construction in that era was a dangerous undertaking to say the least! The spire can be seen waiting on the ground in front of the horse and wagon, ready to be hoisted into position. A bowler hat marks its destination point atop the steeple. (Courtesy of "Life and Industry in Two Rivers: Photos and Catalogs.")

The new St. John's Evangelical Lutheran Church was completed in 1889 at a cost of $10,000. The old church, on the left, was used as the congregation's school building until 1905, when a new school was built. Wooden sidewalks can be seen around the churches. The 1889 church building is listed in the National Register of Historic Places. (Courtesy of "Life and Industry in Two Rivers: Photos and Catalogs.")

The interior of the new St. John's Lutheran Church was designed with the sweeping church architecture popular around the turn of the century, while maintaining simplicity in its decor and furnishings. This view is from the altar area, looking west toward the choir loft. All services were held in German until 1913; the last German service occurred in 1958. (Courtesy of "Life and Industry in Two Rivers: Photos and Catalogs.")

Fr. Joseph A. Geissler was pastor when the new St. Luke Catholic Church was dedicated on October 23, 1892. The cost of the church was $22,483.14. The St. Luke church building is listed in the National Register of Historic Places. The parish rectory, seen on the left, was built in 1895 and is also listed in the National Register. (Courtesy of St. Peter the Fisherman Catholic Parish.)

The interior of St. Luke was remodeled numerous times in the more than 100 years that it served the Two Rivers Catholic community. Here, the church has been repainted, the pews refinished, and the general decor simplified. It was the last church remodeling before major changes in the physical arrangement of Catholic churches were implemented following the Vatican II Council of the 1960s. (Authors' collection.)

St. Mark Catholic Church, a daughter parish of St. Luke, was formed in June 1924 to serve the needs of south side Catholics. Fr. Peter J. Nilles, a Two Rivers native, was the first pastor. St. Luke Parish purchased the church site at Eleventh and Victory Streets. This is the church in the 1930s; note that south side streets remain unpaved. (Courtesy of the Two Rivers Historical Society.)

The Knights of Columbus was founded in Connecticut in 1881 as a Catholic fraternal organization. Fourth-degree is the highest obtainable rank within the Knights of Columbus. The Two Rivers Fourth-degree Assembly was installed in 1949. In 1951, it included, from left to right, William Ahearn, Donald Bero, Dr. Charles J. Klein, Rev. Edward Wagner, Roland Becker, Charles Klein, James Londo, and Clarence Brocher. (Courtesy of St. Peter the Fisherman Parish.)

Eight
Rest and Relaxation in the Cool City

Two Rivers residents had leisure-time experiences that were available in most small towns but also relaxed and played in ways that were unique to the city. Activities included community-based athletics and recreation on the water, Two Rivers's greatest attraction. Distinct artistic, architectural, literary, and musical accomplishments occurred, and another pervasive and persistent attraction was the restaurant and tavern culture. (Photograph by Jeff Dawson.)

Virtually every small American city grew up around a public square; Two Rivers was no exception. Two Rivers's public square was named Central Memorial Park. This 1910 image shows people relaxing in the park and features an excellent view of the first bandstand. Compare this image with page 16 to see how the park developed in 25 years; tree growth was dramatic! (Courtesy of the Manitowoc County Historical Society.)

Central Park and Lakeshore Park were the first parks in Two Rivers. Lakeshore Park has evolved greatly, due largely to the repositioning of Memorial Drive. In 1913, the park was at its recreational zenith with walking/bicycling paths and impressive flower beds. The 1929 plans to construct a swimming pool at Lakeshore Park were abandoned when the J.E. Hamilton Community House was built. (Courtesy of the Two Rivers Historical Society.)

Development at Neshotah Park began during the 1920s as the population of an industrial city began to appreciate the recreational benefits of its undeveloped wooded areas. But, this area of the city had been identified as unique long before the 1920s. In 1835, Joshua Hathaway bought tracts of land near Lake Michigan in numerous cities. His investment proved profitable everywhere except Two Rivers, where neither he nor his heirs could find buyers for the beach property. The city bought the entire Hathaway Tract in about 1920 for $12,000. The western portion of the Hathaway land was subdivided and developed as residential properties. The 50 acres adjacent to the lake, known to local residents as "the Pines," was retained for a city park. Two tennis courts, pictured at left, had recently been built at the time of this 1927 photograph. They were the first Neshotah Park amenities. This view looks south from the location of the future Walsh Field along what was eventually to become Pierce Street. (Courtesy of the City of Two Rivers.)

Neshotah Park improvement was funded in the 1930s by the Civil Works Administration and the Works Progress Administration, New Deal agencies employing the unemployed. The most dramatic project was construction of a lily pond, waterfall, and rock garden of weathered limestone near the north boundary of the park. Vestiges of the lily pond and rock garden remain today, adjacent to Twenty-second Street. (Courtesy of the City of Two Rivers.)

Despite Lake Michigan's moderating effect, winter is a defining aspect of life in Two Rivers. Captioned "King Winter versus Walsh Field," this 1940 photograph captures the peace and serenity, along with the pervasiveness, of winter. Walsh Field was built using federal funds alleviating unemployment during the Great Depression. Walsh Field was dedicated to Thomas Walsh on June 27, 1935. (Courtesy of the Manitowoc County Historical Society.)

Braun's photography studio organized this emblematic 1890 image of Two Rivers mothers and babies, titled "Babies and Buggies." Babies were plentiful, wooden sidewalks were adequate for strolling, and Braun was impressed by the wide variety of baby carriages he saw passing his shops in the 1600 block of Washington Street. Note the horse-shaped hitching post in the foreground. (Courtesy of "Life and Industry in Two Rivers: Photos and Catalogs.")

In a decidedly unusual circumstance, cheery 1940s Christmas decorations stretch over Two Rivers's downtown intersections . . . with the remarkable absence of snow! Anything other than a white Christmas is rare along the Northeast Wisconsin Lake Michigan shoreline. For years, Two Rivers was renowned for its Christmas decorations, especially Central Park's "Christmas Tree Lane." (Courtesy of "Life and Industry in Two Rivers: Photos and Catalogs.")

On a sweltering July 1937 day, workers at Fourteenth and School Streets turned over a shovelful of dirt to discover a four-foot mound of snow! It made national news and led to the inception of the Snow Festival—Two Rivers's most popular event for decades. Ernst Sontag, superintendent of the streets department from 1931 to 1939, poses with the fabled snow. (Courtesy of "Life and Industry in Two Rivers: Photos and Catalogs.")

Discovery of summer snow in 1937 prompted Two Rivers to hold a Snow Festival. The festival became an annual celebration for decades, with the crowning of a snow queen and a court of princesses, chosen from local contestants. Ruth Henfer (Glandt), center, was the first queen. Her princesses were Loretta Flentje (Wilsman), left, and Doris Strong (Otis). (Courtesy of William P. Glandt.)

The Snow Festival was Two Rivers's prime summer celebration until being discontinued in the late 1940s. Revived around 1960 and celebrated continuously for almost 20 years, it was eagerly anticipated, and during the 1960s, residents wore buttons to advertise and promote the event. In 1963 the buttons featured a smiling snowman proclaiming, "I'm on My Way." Holiday House of Manitowoc produced the buttons. (Image courtesy of the Two Rivers Historical Society.)

The Snow Fest was an event that residents of Two Rivers looked to for entertainment and socializing. It was a multifaceted affair, featuring a large parade, snowball fight, a snow queen competition, carnival, food, fireworks, and live music. The parade always featured a dump truck full of carefully preserved winter snow. Sharon Schroeder was that year's snow queen. (Courtesy of "Life and Industry in Two Rivers: Photos and Catalogs.")

April 1931 marked completion of the Hamilton Community House, birthed by the inspiration and generosity of J.E. Hamilton. The building was intended as a public gathering and recreation center for all city residents, boasting a gymnasium, bowling alley, meeting rooms, and kitchen facilities. Remodeled, it remains in use today and is in the National Register of Historic Places. (Courtesy of "Life and Industry in Two Rivers: Photos and Catalogs.")

From 1925 through the late 1950s, the Rivoli Theater represented Saturday afternoon fun for kids and a date destination for couples. At 1816 Washington Street, it could seat 1,000. Husky's Candy and Popcorn was adjacent to the south. Upon becoming Evans' Department Store, the building was expanded and given a modern look. The stage house can still be seen from the rear. (Courtesy of the Two Rivers Historical Society.)

Baseball was all the rage around 1900, and Two Rivers participated fully. The city team was known as the "Colts." Members included, from left to right, (first row) Jule Neuman, Reuben Pilon, and Anton Breivogel; (second row) William Krueger, Walter Johannes, manager John Weilep, Anthony Geimer, and Walter Wieghard; (third row) umpire Joseph Shekoski, Julius Belz, Rudolph Tegen, and Frank Weiss. (Courtesy of "Life and Industry in Two Rivers: Photos and Catalogs.")

After the invention of basketball in 1891, the Reach Athletic Club was an early lakeshore success, winning Wisconsin state championships from 1902 to 1906. The 1904–1905 team included, from left to right, (first row) William Reid, Frank Lamach, and Emil Lamach; (second row) Julius Belz, manager Dr. Joseph Eggers, and Gus Belz. Otto Stangel, not pictured, and Frank Lamach were the leading players. (Courtesy of "Life and Industry in Two Rivers: Photos and Catalogs.")

The Katzenjammer Club held summer picnics on the rivers at the turn of the 20th century. On their custom-built vessel, the *Katzenjammer,* members traveled up the rivers, landed, picnicked, and enjoyed a warm evening cruise home. The club was the brainchild of Robert H. Suettinger, shown here third from the left on the lower level. This was a September 6, 1903, outing. (Courtesy of "Life and Industry in Two Rivers: Photos and Catalogs.")

The rowers seen here were working their way through the spot in the East Twin River known to locals as Still Bend, because of the way the river slowed at this point to form a wide marsh. Frank Lloyd Wright referred to the house he built in Two Rivers as "Still Bend," since it was situated near this point. (Courtesy of "Life and Industry in Two Rivers: Photos and Catalogs.")

The Schmitt family was well known in Two Rivers's history for contributions to industry, business, and music (page 120). The family also developed the first golf course in Two Rivers on land northwest of the city. Beginning in the 1940s, the golf course property was developed into the Edgewood subdivision, west of Mishicot Road and north of Thirty-second Street. (Courtesy of "Life and Industry in Two Rivers: Photos and Catalogs.")

Ice-skating was once a very popular winter recreational activity. The city provided rinks west of Koenig School playground on the south side, at old East Side Park (Twenty-second Street and Lincoln Avenue), at Washington Park on Twenty-seventh Street, and at J.F. Magee School on the north side. The fun seen here took place at Washington Park. (Courtesy of the Two Rivers Historical Society.)

Softball was a major 1960s recreational activity. The 1962 Wisco's Bar team included some of Two Rivers's best softball players. Pictured are, from left to right, (first row) Leo Puls, Howie Puls, Francis "Toby" Peronto, and Paul Ruthmansdorfer; (second row) Del Thielbar, Hank Kotarek, Walter "Sonny" Kotarek, John Schepper, Harold "Sonny" Zeman, and Jerry Messman. Wisco's Bar, owned by Victor Wisniewski, was located at 1523 Jefferson Street. (Courtesy of the Two Rivers Historical Society.)

The beautiful, wide sand beach at Neshotah Park is the city's gem on the lakeshore. Two Rivers was already acknowledged as an excellent spot for "bathing" by 1912, and Two Rivers's climatically distinctive reputation was well established by World War II. The original caption of this 1944 photograph proclaims, "On the beach at Two Rivers, the coolest spot in Wisconsin." (Courtesy of the Two Rivers Historical Society.)

Visitors to Two Rivers in the 1940s were welcomed with a sign touting the city's connection to professional football. That claim was not without veracity! Four professional teams trained in Two Rivers. The Pittsburgh Pirates (later the Steelers) of the National Football League, coached by the legendary Johnny "Blood" McNally, held summer training sessions in Two Rivers in 1939. In 1940, the city hosted the Columbus Bullies of the American Football League, a short-lived professional circuit. The Bullies went on to win the American Football League Championship after training in Two Rivers in 1940. The National Football League's Philadelphia Eagles trained in Two Rivers twice, in 1941 and 1942. In 1947, the Chicago Rockets of the All American Football Conference were the last professional team to train in Two Rivers. Washington High School, the J.E. Hamilton Community House, and Walsh Field were utilized for practices and meetings while teams stayed at the Hotel Hamilton. Cool weather, good quality athletic facilities, and the hospitality of the city residents lured all of the teams to the city. (Authors' collection.)

The Sojourner

Dedicated to our Native Sons and Daughters Serving in the Armed Forces of our Country

Volume IV TWO RIVERS, WISCONSIN, DECEMBER, 1945 Number 10

Standing left to right: Kathleen Dufano, Gertrude Kaminsky, Gertrude Doncheck, Rose Marek. Seated left to right: Gladys Schaden, Jeanette Bonfigt, Anita Tegen, Ruth Feuerstein, Marjorie Stanull, Maryon Lintereur, Marion Wyzinski. Marie Klein not present when picture was taken.

Merry Christmas and A Happy New Year!

"Everywhere, everywhere Christmas tonight."
Wherever you are
May yours be just right.
—Jeanette Bonfigt

You have all expressed your gratitude in being able to hear about your friends through the Sojourner. In turn, we have been able to keep in touch with all of you. Working for you has been a pleasure. Merry Christmas!
—Gladys Schaden

I want to express a "special thanks" to all the boys who found time to write us those nice letters, no matter how short, they were appreciated. I hope you all have time to enjoy Christmas and to celebrate the coming of the New Year.
—Ruth Feuerstein

It's been fun helping get the paper out to you, fellows. From the letters received, you've seemed to enjoy it and that made the work worth-while. With extending the Season's Greetings, I also send wishes for a speedy return home.
—Rose Marek

My days on the staff are nearing an end So greetings to you I now want to send.
May Santa be good to you Christmas night And may all your days be happy and bright.
—Gertrude Kaminsky

The Merriest of Christmases and Happiest of New Years to all and especially our classmates from the class of '44. Two Rivers will never be the same until each of you is home again.
—Kathleen Dufano and Maryon Lintereur

A Merry Christmas and a Happy New Year to all of you on this, our first Christmas in a world of peace. May you be at home next Christmas.
—Marjorie Schroeder Stanull

It certainly has been a pleasure working on the Sojourner for all of you. Hope you are all home for next Christmas. Until then, Merry Christmas and a Happy New Year.
—Anita Tegen

It was swell being able to keep in touch with all of you fellows through the paper. Hope we'll be seeing you all soon. Merry Christmas!
—Marion Wyzinski

Literary endeavors have been a part of the cultural scene in Two Rivers throughout its history. However, there was probably never a more heartfelt literary endeavor than the publication of the *Sojourner*. The newspaper was published from 1943 through 1945, "dedicated to our native sons and daughters serving in the armed forces of our country." The *Sojourner* was sent to all who were serving in the military, sharing Two Rivers news. It also published letters from those in service, thereby facilitating an exchange of information among those away from home during the war. Sponsored by Veterans of Foreign Wars Post No. 1248, the paper was printed at the Vocational School Print Shop. Ewald J. Schmeichel was advisor. The cover from the last issue of the newspaper pictured the staff. From left to right are Gladys Schaden, Kathleen Dufano, Jeanette Bonfigt, Gertrude Kaminsky, Anita Tegen, Gertrude Doncheck (editor), Ruth Feuerstein, Rose Marek, Marjorie Stanull, Maryon Lintereur, and Marion Wyzinski. Marie Klein was absent. (Authors' collection.)

Lester W. Bentley (1908–1972), above, was born and taught art classes in Two Rivers. He went on to become nationally renowned and Two Rivers's most famous artist. He is best known for presidential portraits created for the Works Progress Administration in the 1930s. While Bentley eventually moved his primary residence to Greenwich, Connecticut, he remained loyal to Wisconsin, and much of his artwork resides in Wisconsin museums. Bentley maintained studios in both Two Rivers and Greenwich. In the photograph below from the 1950s, he was painting a landscape at a local street festival. Other examples of his work can be seen in the background. In 2006, the Two Rivers Historical Society purchased the Frick Collection of Bentley artwork. The collection is permanently displayed at the Lester Public Library. (Both courtesy of "Life and Industry in Two Rivers: Photos and Catalogs.")

The Schmitt Brothers Quartet achieved greater acclaim than any other musical performers from Two Rivers. Sons of Henry Schmitt, and four of 17 children, the Quartet began singing publicly in 1949. In 1951, they won the international championship of the Society for the Preservation and Encouragement of Barbershop Quartet Singing in America. Success in this competition led to national notoriety for the Schmitt Brothers, including an appearance on the Ed Sullivan Show. Over the next 34 years, they entertained more than 3,000 barbershop audiences, traveling more than two million miles. This distinctive image is the front of a Schmitt Brothers Quartet Christmas greeting card from the 1960s. Pictured, from top to bottom, are Joseph Schmitt (1926–1985), tenor; James Schmitt (1931–2008), lead; Paul Schmitt (1928–1986), baritone; and Francis Schmitt (1916–1991), bass. Schmitt Brothers recordings remain popular with barbershop quartet fans in Two Rivers and elsewhere. (Authors' collection.)

Lydia Clarke Heston is perhaps Two Rivers's most famous daughter. Lydia, daughter of L.B. Clarke, Washington High School principal for over 30 years, met Charlton Heston at Northwestern University in 1941. Three years later, on March 17, 1944, they were married. The Hestons were noted for their generosity to Two Rivers, and their visits to the city were eagerly anticipated. (Courtesy of the Two Rivers Historical Society.)

The apex of Two Rivers's architecture is the Bernard Schwartz house at 3425 Adams Street, a spot on the East Twin River known as Still Bend. Frank Lloyd Wright developed the house design in 1938. Believed to have the oldest continuously operating in-floor heating system in the country, the house is one of the few Wright homes that allows guests to spend the night. (Photograph by Cassandra Gagnon Kronforst.)

The Washington House at 1622 Jefferson Street is one the most historic buildings remaining in Two Rivers. Built in 1850, the Washington House was a 19th-century three-story inn and public house. During the 19th century, it provided lodging for Two Rivers newcomers, transients, and a few regular tenants. Meals were served, and a bar room occupied a portion of the first floor. In this early-20th-century photograph, 19 adults and children assembled on the Jefferson Street side of the Washington House. After years as Falk's Bar, an establishment rarely open to the public in its later years, the building was destined for the wrecking ball. But, it was purchased by the Two Rivers Historical Society and has become a prominent Two Rivers tourist destination. It features the authentic tap room; a ballroom with unique, professionally restored ceiling murals; an old-fashioned ice cream parlor; and many rooms devoted to historic displays. Much of the original decor has been preserved. The building is listed in the National Register of Historic Places. (Courtesy of the Manitowoc County Historical Society.)

The Lake House opened in 1857 on the southeast corner of Washington and Sixteenth Streets, offering lodging, food, and drink. Peter Rau bought the establishment in 1882. The Lake House was a prime Two Rivers spot for socializing, as seen on this warm July 26, 1911. Gathered were, from left to right, (first row) Raymond Schneider; Charles F. Kirst, who later built his drugstore at this location; Melvin Krause; Peter Bartelme; and Walter Hamilton; (second row) Nic Rau, F.F. Willard, Walter Mann, Frank E. Riley, Noel Nash, Gustav Kirst, Walter Mauer, Edwin R. Mueller (Yes, he is from the Mueller Brothers' Brewing Company that produced the cases of now-empty bottles in the picture!), Harry R. Hurst, Orme A. Voshardt, William Fetkenheuer, and Robert Suettinger. (Above, authors' collection; below, courtesy of "Life and Industry in Two Rivers: Photos and Catalogs.")

An enduring Two Rivers landmark was born when Michael Bartelme began efforts to acquire property at the corner of Main (Sixteenth) and Jefferson Streets to construct a fine hotel. He sold half interest in the project to Peter and Jonas Gagnon. Construction, seen at left, occurred during the summer. The Waverly Hotel, with its unique castle-like architecture, opened on October 4, 1892, with a banquet and music by the Union Coronet Band. (Courtesy of "Life and Industry in Two Rivers: Photos and Catalogs")

The bar room was added in 1893, the year that Bartelme died. Indoor plumbing was installed in 1895. The Gagnons retired from the business in 1898. Bartelme's widow, Odella, operated the hotel until 1905. Numerous owners followed. The pyramid-roofed corner tower was removed in 1965. This sketch was drawn in 1899. (Courtesy of the Two Rivers Historical Society.)

When the 18th Amendment was ratified in 1920, proprietors of taverns thought creatively to maintain their incomes. Hansen's Tavern, built in 1893 at 1606 Washington Street, was transformed into the Diamond Buffet. When Prohibition ended in 1933, tavern life returned to normal, and the establishment became the Diamond Bar. The building is in the National Register of Historic Places. (Courtesy of "Life and Industry in Two Rivers: Photos and Catalogs.")

Built in the 1940s by Clem Michels and Erhardt Mueller, the M&M Lunch originally had its entrance on Washington Street, unobstructed by a widened Washington Street Bridge. Initially proclaiming itself "Two Rivers's swanky fish shanty," it is the oldest continuously functioning restaurant in Two Rivers. The restaurant has been owned by Leigh and Judy Stegemann since 1977. (Courtesy of the Manitowoc County Historical Society.)

Smiling from his tavern door was Emmet "Bucky" Mertens, owner of Bucky's Tavern at 1911 Jefferson Street. Bucky's was a popular spot during World War II and a favored stop for young couples in the years after the war. With Bucky were two patrons, Ruth Waskow, left, and Rose Marek. The establishment became Wally's Bar in the 1960s and, in the 1980s, Glandt's Ship's Inn. (Authors' collection.)

Formerly a stagecoach station and hotel, the building at 1713 East Street was constructed by Louis Gauthier. Edward Kreisa operated it in the 1940s as the Pioneer Tavern. Bill Henfer bought the business and building in 1950. When this photograph was taken, Henfer had completed major exterior renovations. Subsequently, it became Harold and Em's, Big Lew's, and, finally, Tippy's Bar and Grill. (Courtesy of William P. Glandt.)

Sunset and evening star,
And one clear call for me!
And may there be no moaning of the bar,
When I put out to sea.

But such a tide as moving seems asleep,
Too full for sound and foam,
When that which drew from out the boundless deep
Turns again home!

Twilight and evening bell,
And after that the dark!
And may there be no sadness of farewell,
When I embark;

For though from out our bourn of Time and Place
The flood may bear me far,
I hope to see my Pilot face to face
When I have crost the bar.

—Alfred, Lord Tennyson
"Crossing the Bar"
(Photograph by Jeff Dawson.)

Discover Thousands of Local History Books Featuring Millions of Vintage Images

Arcadia Publishing, the leading local history publisher in the United States, is committed to making history accessible and meaningful through publishing books that celebrate and preserve the heritage of America's people and places.

Find more books like this at
www.arcadiapublishing.com

Search for your hometown history, your old stomping grounds, and even your favorite sports team.

Consistent with our mission to preserve history on a local level, this book was printed in South Carolina on American-made paper and manufactured entirely in the United States. Products carrying the accredited Forest Stewardship Council (FSC) label are printed on 100 percent FSC-certified paper.

MADE IN THE USA